PENOBSCOT
BAY

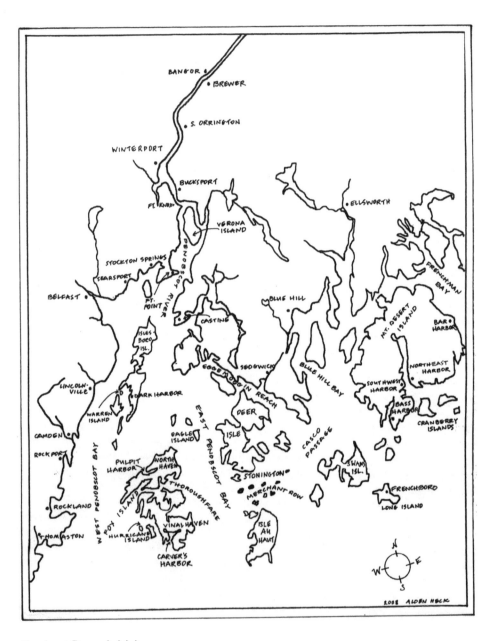

Penobscot Bay and vicinity.

PENOBSCOT
BAY

········•········

PEOPLE, PORTS & PASTIMES

HARRY GRATWICK

Charleston London

THE
History
PRESS

Published by The History Press
Charleston, SC 29403
www.historypress.net

Copyright © 2009 by Harry Gratwick
All rights reserved

Cover photograph by Geoffrey Gratwick.

First published 2009

Manufactured in the United States

ISBN 978.1.59629.623.7

Library of Congress Cataloging-in-Publication Data

Gratwick, Harry.
Penobscot Bay : people, ports and pastimes / Harry Gratwick.
p. cm.
Includes bibliographical references.
ISBN 978-1-59629-623-7
1. Penobscot Bay Region (Me.)--History. 2. Penobsoct Bay Region (Me.)--Social life
and customs. 3. Penobscot Bay Region (Me.)--Biography. 4. Vinalhaven Island (Me.)--
History. 5. Vinalhaven Island (Me.)--Social life and cutoms. 6. Vinalhaven Island (Me.)--
Biography. I. Title.
F27.P37G736 2009
974.1'3--dc22
2009001704

The sea became my unspoken challenge: the wind, the tide, the fog, the ledge, the bell, the gull that cried help, the never-ending threat and bluff of weather.

–*E.B. White*

CONTENTS

Contents

FOREWORD

E very place has a history, of course, but sometimes that story is particularly rich. Such is the case of Penobscot Bay in Maine. One of the East Coast's great bodies of water, Penobscot Bay has witnessed significant events from the times of the earliest European explorers and the American Revolution to the present. Deep and navigable, rich in resources and at times strategically important, Penobscot Bay and the long river that empties into it from interior Maine have been battlefields and highways, sources of great wealth and backdrops for events that changed lives far beyond the bay itself.

Harry Gratwick has spent many summers on an island in Penobscot Bay, absorbing this region's multilayered history in different ways: as a diligent researcher in local historical societies; as a good listener and collector of stories; and as a gifted writer with a feel for what's really interesting to readers.

I first became acquainted with Harry as his editor at *Working Waterfront* and *Island Journal*, two publications with a deep interest in the history of coastal Maine and its island communities. Many years ago, he began coming to me with story ideas that just got better and better—where the granite from Vinalhaven's quarries ended up; how Franklin D. Roosevelt fooled everyone into thinking he'd gone fishing when he was actually meeting with Winston Churchill; when islanders really took their baseball seriously; how an island goes to war. He has profiled historic vessels such as Monhegan's venerable mail boat and written about the little boats that summer folks race in the Fox Islands Thorofare and about rumored sightings of German submarines in the bay during World War II. Not all of his story ideas were entirely original—I'd read versions of some of them in other places—but Harry's take on each one was original and made me want more. The variety is endless, and it keeps on coming.

Harry taught history and coached baseball at Germantown Friends School in Philadelphia for many years, and his writing reflects the interests that must have led him into the classroom in the first place: people, events and the

way ordinary happenings like the availability of a particular resource or a change in the weather or how the arrival of the right person at the right time and place can change history and affect everyone else's life. He's a great interviewer and quote collector; if he hadn't been a teacher, I suspect he would have been a very good newspaper reporter. Of course, in Harry's case, he would have covered sports, particularly baseball, about which he is passionate. When he retired from teaching a few years ago, the school named its ball field for him.

Harry and Penobscot Bay are well matched, and it's not surprising that he has written so much about this beautiful and historic place. The bay has had many chroniclers over the years, and I'm confident that Harry will one day be known as one of the best.

David D. Platt

David Platt is former editor of Working Waterfront *and* Island Journal, *both publications of the Island Institute, Rockland, Maine.*

Acknowledgements

This book could not have been written without the ongoing assistance of Bill Chilles, Sue Radley, Roy Heisler and others at the Vinalhaven Historical Society. And Nan Lee at the North Haven Historical Society should know how much I appreciate all of her help, as well as that of Bud Thayer, Collette Haskell, Herb Haskell, Herb Parsons and George Lewis.

I would like to thank David Platt and David Tyler, editors past and present at the *Working Waterfront*, for their support, as well as Lance Warren at The History Press, who sold me on the idea of a book in the first place and provided skillful guidance throughout the process.

I am very grateful to Dennis Pratt, Steve Ames, Chuck Curtis and Roman Cooper for their basketball recollections, as well as John Shiffert, Brud Carver, Ducky Haskell, Buzz Young and Paul Chilles for their baseball memories. Other folks who supplied a great deal of help and information include Paul Pendleton from Islesboro; Gil Merriam and the Rockland Cooperative History Project; Jack Elliot's brother John and his shipmates Art Tilley and Gerry Dupuis; Bill Cook at the Bangor Public Library; Rachel Kotkoskie at the Photo Workshop in Philadelphia; and Paul Berry at the Calvert Marine Museum.

Special thanks to "Earl on the River" Morrill, and kudos to my longtime colleague, Denny Heck, at Germantown Friends School for her map. Finally, a salute to my brothers, Joel and Geoffrey Gratwick, for their advice on all matters nautical and to my wife, Tita, for her love, her unfailing patience and, most importantly, for her editorial expertise.

INTRODUCTION

From a child's perspective, most of what I remember about World War II involved shortages and strict rationing. Rationing, including gas and rubber, meant that my family couldn't drive to Vinalhaven for our summer vacation. By the summer of 1945, however, Germany had surrendered and the war in Europe was over. With the easing of rationing restrictions, my parents were able to accumulate enough gas coupons to make the trip to Maine from our home in Tarrytown-on-Hudson, New York.

The drive north, with my four brothers and sisters and a dog crammed into our car, must have been a nightmare for my parents. Remember, this was before the days of I-95 and SUVs. Although the Maine Turnpike was begun in 1947, it was not completed until 1955. This meant that we had to take Route 1, which was mostly two lanes in the 1940s. After an endless trip, we finally arrived in Rockland in the middle of the night without a place to stay. I remember the night man at the Thorndike Hotel reluctantly letting us sleep on couches in the lobby for a few hours before waking us up in time to catch the 7:00 a.m. boat. We didn't take our car to Vinalhaven in 1945. The ferryboat was *Vinalhaven II*, which had space to carry two vehicles. If it was foggy, cars were not permitted because they threw off the boat's compass.

By modern standards, we led a simple life on Vinalhaven in the summers following World War II. We had no electricity or phone, and my mother did our cooking on a two-burner kerosene stove. We burned our trash below the tide line and sank our cans and bottles in the ocean off our float. We had an outhouse, which was emptied, along with the garbage, into a pit in the woods. (I hate to think of the number of environmental regulations we were violating by today's waste disposal standards.) Water was pumped from a twelve-foot well that my father had dug a few years before. Refrigeration was literally an "ice box," with a ten-pound cake of ice that kept milk, butter and eggs cool for a few days. In 1949, we began to take outdoor showers similar to the one Mary Martin used in the Broadway show *South Pacific*, which

opened that year. Remember "I'm Gonna Wash That Man Right Out of My Hair"? Before that year, it was either the ocean or a sponge bath in the kitchen sink.

Highlights of our summers included going "down street" in Charlie Creed's taxi, one of the few cars on the island. Sometimes we hiked to George and Gracie's store in Dogtown for ice cream, a mile down the road. Although the ocean was colder than it is today, we did most of our swimming off the rocks in front of our boathouse. My father was an expert with canoes, so on sunny days we often paddled to nearby islands for picnics. I was told that local lobstermen thought we were crazy to go out in the ocean in canoes. Perhaps we were.

In August, the war in the Pacific ended with the surrender of Japan. One of our neighbors was the Baker family who lived on nearby Cedar Island. The Bakers had a radio and told us that they would shoot off fireworks when they heard the news. Late in the afternoon of August 15, all hell broke loose over on Cedar Island. The Bakers not only shot off fireworks, but they also rang their bell and fired their ceremonial cannon a few times for good measure. The war was finally over.

Lobstering then, as now, was a big part of the economy of coastal Maine, though no one set as many traps as they do today. Maynard Sweat lived nearby and hauled fifty to sixty traps from his dory in the waters on the western side of Vinalhaven called the Red Sea. Another neighbor, Arnold Barton, had a thirty-five-foot boat, *Janice Elaine*. Having a larger boat meant he could set more traps over a wider area. One thrilling day, we were invited to go out hauling with him. By the end of the trip, I realized the hard work involved in hauling lobster traps. Although there may have been a few stern men in those days, Arnold didn't have one until his oldest son got old enough to help him.

Arnold also fished for herring, an exhausting job. The object was to trap a school of herring in a cove or weir and slowly encircle it with a net, a laborious and time-consuming job requiring a crew of men. At one point, Arnold and his helpers trapped a school of herring in Fisherman's Cove, close to our house. That night we were awakened by men shouting and banging on the sides of their boats at the edge of the cove. The next morning, we learned that the herring had attracted a whale, which had broken through the nets to feed on them. Arnold and his crew were doing their best to dislodge the leviathan without getting too close to him. Although there continue to be enough lobsters to sustain the lobstermen on Vinalhaven, herring fishing in Penobscot Bay has pretty well disappeared.

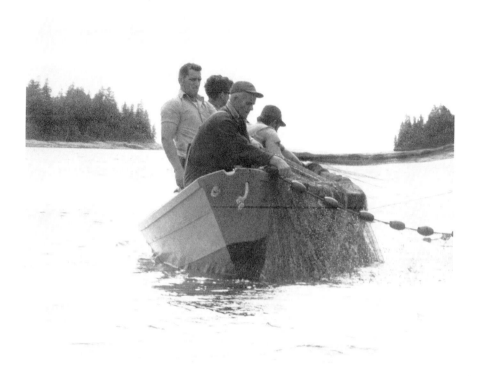

Herring fishing, mid-twentieth century, Fisherman's Cove, Vinalhaven. Herring fishing was a time-consuming and laborious job. *Courtesy of Geoffrey Gratwick.*

All of this took place over sixty years ago. Life on Vinalhaven and in the other communities on Penobscot Bay has changed dramatically, as it has throughout the country. Many of the following stories reflect what island and coastal life was like in earlier times. A number of them have appeared in the *Working Waterfront* and *Island Journal*, published by the *Island Institute*. I hope you enjoy them.

A PENOBSCOT PASSAGE

From Vinalhaven to Bangor

Penobscot Bay is the centerpiece of mid-coast Maine. It is framed on the west by the mainland towns of Rockland and Camden and to the east by the islands of Deer Isle and Isle Au Haut. In the center of the bay lie a cluster of islands that surround the offshore communities of Vinalhaven and North Haven. The 350-mile-long Penobscot River, the second longest in Maine, flows into the northern part of the bay.

A trip by boat from Vinalhaven to the city of Bangor, thirty miles up the Penobscot River, is a journey rich in history and scenery, a trip past a number of vigorous waterfront communities. Several years ago, my wife and I traveled by boat to Bangor to join my brother Geoffrey for his sixtieth birthday celebration. We stopped along the way at the towns of Castine, Searsport, Bucksport, as well as Fort Knox, on our passage north. On our return trip, we visited Fort Point State Park, Belfast and Islesboro.

In the late nineteenth century, Vinalhaven and Stonington, on Deer Isle, were major centers for the granite industry on the East Coast of the United States. The remnants of the three dozen quarries on Vinalhaven are still visible, several of which are still being worked today. In the mid-twentieth century, the island economy began a shift to fishing, and today Vinalhaven has the largest lobster fleet on the East Coast, some say in the country. Vinalhaven's year-round population of 1,300 is a mixture of old island families, retirees and artists. This number increases dramatically in the summer months with the addition of summer residents and day-trippers.

In the last twenty-five years, Vinalhaven Island has been spared some of the coastal building boom, due to the efforts of the Vinalhaven Land Trust and the Maine Coast Heritage Trust. In the fall of 2008, the *Bangor Daily News* broke a front-page story about the beautiful Basin area, described as a "model of conservation and preservation." The article related how "a

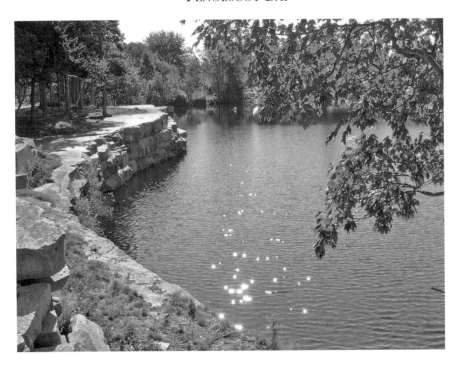

Booth's Quarry, Vinalhaven. The remains of many of the old quarries are still visible on the island today. Booth's Quarry is a favorite swimming hole for island residents. *Courtesy of Susan Rankin.*

protective envelope" of nearly one thousand acres surrounds this island tidal inlet. The Basin was cited as one of the island's most popular visitation spots, with a variety of wildlife, as well as an active picnic and kayak area, protected for future natural enjoyment by all.

North Haven has a smaller year-round population than its southern neighbor. Originally referred to as the North Island on eighteenth-century charts, North Haven is the second largest of the islands in the middle of Penobscot Bay known collectively as the Fox Islands. Permanent settlers began to arrive on the North Island in the 1760s, and by the early nineteenth century, it had become a prosperous farming community. It is interesting that in 1846 the North Island separated from Vinalhaven and for a year was known as "Fox Isle" before becoming North Haven. The island reached a peak year-round population of 950 shortly before the Civil War. "Summer-people" discovered North Haven in the late nineteenth century, and in the twentieth century the island developed into a popular vacation spot for the well-to-do originally from the Boston area.

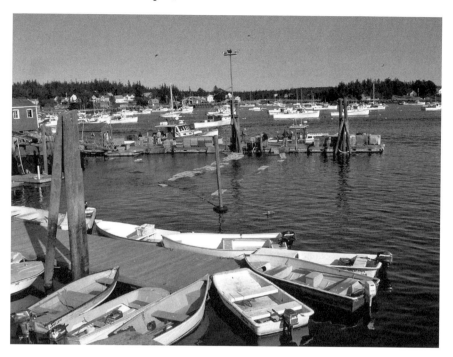

Vinalhaven Harbor, present day. Vinalhaven has the largest lobster fleet on the East Coast. *Courtesy of Susan Rankin.*

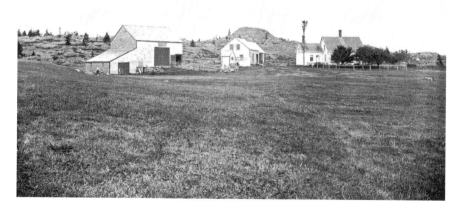

Lewis Ames Farm, North Haven. In the nineteenth century, North Haven was a prosperous farming and fishing community. *Courtesy of the North Haven Historical Society.*

Castine and the Penobscot Expedition

From North Haven, we journeyed to Castine, a town of shady streets and gracious houses twenty miles northeast of North Haven. Castine's early history, however, was anything but peaceful. From its beginnings as a trading post in 1629, the town was the center of conflicts involving England, France and colonial America. During the American Revolution, the British built a fort that would give them a base from which to harass Rebel shipping. In 1779, when word of the British operation reached Boston (Maine was part of Massachusetts until 1820), authorities sent a fleet to attack the base. Commodore Dudley Saltonstall, "an able man possessed of an extremely obstinate disposition," was put in overall command. Instead of launching an attack, Saltonstall spent weeks of indecisive maneuvering. The result was the ill-fated Penobscot Expedition, the largest land-sea operation in the Revolutionary War and the worst naval disaster in American history prior to Pearl Harbor.

As the American forces were finally preparing to assault Castine, lookouts spotted the approach of a British fleet led by a sixty-four-gun ship of the line. This caused the entire American fleet to flee in terror up the Penobscot River, despite the fact that it outnumbered and outgunned the British. Today, the remains of eighteen armed vessels and twenty-one transports lie in the mud, from the mouth of the river to the top of the tide line at Bangor. Their panicked crews had destroyed the ships. Some of the men didn't stop retreating until they got to Boston!

The American forces lost all their ships and 474 men were killed, wounded or captured, compared to 13 British casualties. Lieutenant Colonel Paul Revere's reputation was also tarnished. (Reportedly, he returned to Boston in a "towering rage.") As artillery commander, Revere was initially censured by a court-martial, but in 1782 he was cleared of blame. The primary leader of the expedition, Commodore Saltonstall, was found to be responsible for the debacle and, after a court-martial, he was dismissed from the navy.

The earthworks of the British fort (Fort George) still stand at the mouth of the Penobscot in Castine, a reminder of the disaster 230 years ago. Archaeological evidence of the expedition including cannons, cannonballs and scuttled ships continue to be found on the Penobscot River as far north as the Bangor town dock. These days, Castine's waterfront is dominated by the Maine Maritime Academy's training ship *State of Maine*, which is open to the public.

People, Ports and Pastimes

Searsport to Winterport

We crossed the northern part of Penobscot Bay to reach Searsport, another community with a rich, but somewhat different, nautical past. For anyone visiting Searsport, the Penobscot Marine Museum is a "must stop." The museum, and a complex of fourteen buildings, recreates Maine's mid-nineteenth-century coastal world by displaying numerous maritime artifacts and paintings. There is also an impressive library available to scholars and amateur historians alike.

To be master of a deepwater vessel was a family tradition in Searsport. I learned that in the 1880s, captains from Searsport commanded 10 percent of all full-rigged ships sailing under the flag of the United States. In fact, some of their houses remain in use today as bed-and-breakfasts. At the same time, the town and nearby communities became a veritable assembly line for oceangoing ships. Since 1900, Searsport has been an important cargo port, second only to Portland in total shipping tonnage in the state.

We headed northeast to our next stop at Bucksport. First settled in 1764 by Jonathan Buck, Bucksport has been a commercial center for over two hundred years. In the nineteenth century, it was also a major shipbuilding site. In addition, Bucksport's fishing fleet was famous for fishing on the Grand Banks. Today, the buildings of Verso Paper's Bucksport Mill dominate the waterfront. Both pleasure and commercial vessels share a pleasant river harbor.

Directly across the river from Bucksport is Fort Knox, which was built of local granite in 1844 to prevent an invasion that never occurred. In the 1840s, when a boundary dispute arose with the British, the fort was begun. Fort Knox subsequently saw two periods of military activity. Garrisons were stationed there in the 1860s during the Civil War and again shortly before the Spanish-American War in the 1890s. Fort Knox is named after General Henry Knox, a Revolutionary War hero and the first secretary of war in Washington's cabinet. Today the fort is Maine's most visited state historic site. There are no public landing facilities, though the fort is easily reached by land.

The Penobscot River narrows at Winterport, one of the more than two dozen towns along the river and the bay that built oceangoing schooners and brigs from timber processed in Bangor. According to the Winterport Historical Association, "Before the railroad in 1855, most freight and travelers came up river by water. In the winter months, all goods and travelers had to be off-loaded at Frankfort [Winterport] and transported to Bangor and points north by wagons or sleds. Because the river was ice bound beyond this point, it was truly a 'winterport,' making it an important location."

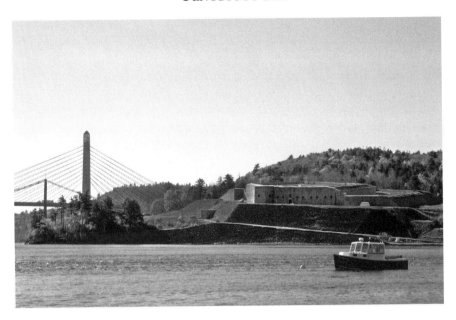

View of Fort Knox from the Penobscot River. Fort Knox was named for General Henry Knox, a Thomaston resident and Washington's first secretary of war. The observation tower at the top of the newly constructed Penobscot Narrows Bridge, in the background, affords a magnificent view of the entire mid-coast Maine region. *Courtesy of John Wombacher/Sundial Photography.*

The landscape began to change as we proceeded up the Penobscot River. In 1830, Maine historian William D. Williamson wrote the following description: "The banks of the river are generally high, some projections are rocky and rugged and others afford a picturesque appearance. An enchanting expanse of river spreads itself north of Bucksport Village…and beautiful country on either side fills the passenger's eye from the river with captivating views of nature and culture." In the 1840s, steam tugs came into use on the river. The currents were so treacherous and the river so crowded that sailing ships found it safer to be towed to Bangor from Fort Point at the mouth of the river.

Earl on the River

Eight miles south of Bangor, I stopped to visit Earl Morrill. He calls himself "Earl on the River" and when you hear his story, you'll know why. Until recently, Earl Morrill was a resident of South Orrington, Maine, who specialized in building scale models of nineteenth-century Maine sailing vessels. I first met Earl several years ago while I was doing research for

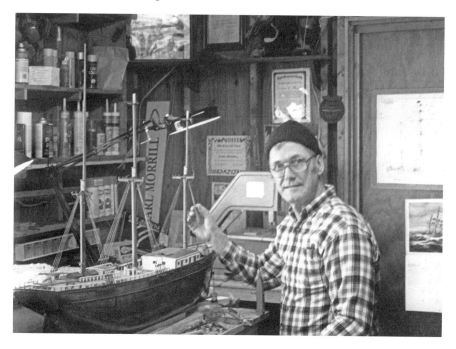

Earl Morrill in his workshop. Earl specializes in building scale models of nineteenth- and early twentieth-century Maine sailing vessels. *Courtesy of Earl Morrill.*

an article on the history of the Penobscot River. I soon discovered that in addition to being a superb builder of historic model ships, Earl was a veritable storehouse of information about the Penobscot River.

Earl was born and raised in a house that his great-great-grandfather built in 1867. From an early age, he remembers hanging out with an old trapper named Joe Hurd who, according to Earl, "had lots of stories to tell about the days of sailing ships on the river." Morrill credits Hurd with teaching him how to row and "get up and down the river no matter what the tide, by using the eddies." He also remembers sailing on the river when he was fourteen in a flat-bottomed rowboat. "I guess it was Old Joe who was the beginning of my maritime studies and my desires to build models of Maine sailing vessels," Earl recalled.

A retired mechanical engineer, Earl has built model ships in his "spare time" his whole life. In the process, he has learned a great deal about shipbuilding and the history of the Penobscot River region. Earl explained that in the nineteenth century there were as many as forty shipbuilding sites on the river. Builders took orders from shipping businesses in New York and Boston and spent the winter months building a variety of oceangoing

vessels. The government subsidized their efforts by providing planking of hard southern pine. Earl estimated that there were as many as 3,400 ships built, including 25 to 30 in South Orrington alone. "There was a lot going on," he said. "In addition to the lumber and shipbuilding industries, there was the ice industry. Ice was cut from the river as well as nearby lakes and ponds, packed in sawdust and shipped all over the world."

Earl's great-great-grandfather, Joseph H. Atwood, was captain of a three-masted schooner, *Charles S. Hazzard*, built in Essex, Massachusetts. In the 1850s and 1860s, *Hazzard* hauled lumber from Bangor down the Penobscot River to Boston and New York three times per year. On return voyages, it would bring back a load of produce. In winters it was "iced into the cove" behind the house that Atwood built on Mill Creek, where Earl still lives. As recently as 1955, Earl remembers there were still a few hulks lying on the shore. "Even today," he says, "there is an old two-master washing out of the cove by Ryders Point, just north of here. The ship was named *Planter* and was used for hauling split wood up and down the river to feed the lime kilns in Rockport."

"All this history, and my great-great gramp being part of it, just got me started researching," Earl remembers. "The more I found out, the more I wanted to build an historic model from the keel up." Earl was in his twenties when he began a model of Atwood's ship, *Charles S. Hazzard*. "I had done the research," Earl recalls. "However, I soon realized that I was way over my head trying to build a model boat." He stopped for three months and gave himself a crash course in shipbuilding. When Earl finally finished *Hazzard*, he admitted, "She was a little crude, but eventually I sold her to the owner of the Harris Company in Portland." The owner, Austin Harris, has since retired, but he told me recently that *Charles S. Hazzard* is prominently displayed in his parlor in Yarmouth.

Earl's second model-building effort was the four-masted schooner *James E. Coburn*. He remembers finding a picture of it while it was being built on Mill Creek in 1919. "Historic model building took a long time in those days," Earl recalls. Mostly this was because of the time it took for research and the fact that everything came by regular mail. Even now, before he begins a project, Earl does months of research on a ship model. His model of *Coburn* can be seen today in the Orrington Historical Society. Earl continued to improve his skills when he next built a model of SS *Roosevelt*, the ship that Admiral Peary took to the North Pole in 1908. Incidentally, Earl's great-great-uncle, Maynard Wardwell, was Peary's chief engineer on that historic expedition. The SS *Roosevelt* was built in 1905 on Vernoa Island, just south of Bucksport. Appropriately, Earl's

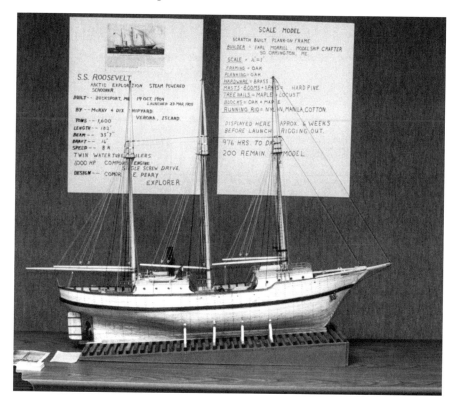

Earl Morrill's model of SS *Roosevelt*. Earl donated the model to the Buck Memorial Library in Bucksport, where it has been on display since 2001. *Courtesy of Earl Morrill.*

model of the ship has been on display in the Buck Memorial Library in Bucksport since 2001.

"By the third ship, you are hooked," he says. "You know you can do a better job on the next vessel and you drive yourself to a higher level of accuracy." Earl works only on Maine sailing ships and insists that they must be documentable and original (the first model to be built). A number of years ago, the owner of a local newspaper saw SS *Roosevelt* on display in Bucksport and asked Earl to build him a vessel. After some negotiating, Earl agreed to build him a historic model of the brig *Telos*, out of Bangor, for $9,000. In this case, his client even agreed to do the research.

Earl is particularly proud of the model he made of *Spitfire*, a fast clipper ship built in 1853. At one point, it held the record of 106 days for the fastest trip from New York to San Francisco. *Spitfire* is currently on display in the Searsport Marine Museum. Earl's research included examining nineteenth-century maps of the Penobscot River area in an effort to locate a slipway

large enough to accommodate a two-hundred-foot vessel. His challenge was that in the nineteenth century, there were forty towns on the Penobscot with slipways for constructing ships and yet he had to find a specific site. After careful study, he found both the slipway and house of the builder, Isaac Dunham, in present-day Winterport. Earl finished the Spitfire in 2000, and it was sold at the Maritime Museum's annual fundraiser for $20,000.

Over the years, Earl has developed a database of more than 4,000 vessels, including 2,800 built on the Penobscot River from 1780 to 1940. Earl has a number of students to whom he sends lesson plans once a week. The lessons are compiled from his old model-building records. "We are all set up with the same graphic software so I can send drawings, pictures and ship plans." Most of his students live in the United States, though Earl says he had a guy from Australia who built a "really nice Maine schooner a couple of years ago. Some guys get it and some give it up."

What lies ahead for this master model shipwright? Earl has been "at it" for over forty years. To date, Earl estimates that he has built twenty historic sailing ships from scratch. Included are eight or nine schooners, one bark, two brigs, three clippers, two frigates and a packet ship. In addition, he figures that he has restored "close to" another thirty ships. "You gotta love it or leave it alone." Quite a guy, that "Earl on the River."

North to Bangor

North of South Orrington is Rooster Rock, where the river takes a ninety-degree turn. The channel meanders and can be dangerous for deep-draft vessels. According to Earl, 9.5 billion feet of timber were processed in Bangor's many sawmills. The rotting bark from slab wood, as well as natural debris, has created mud flats. Although the river is slowly cleaning itself, the channel to Bangor needs to be dredged. Dredging itself presents a dilemma. The Army Corps of Engineers is responsible for doing the work, yet the Navy Department still owns the vessels that were sunk in the 1779 Penobscot Expedition and it wants to retrieve the artifacts from the ships. To further complicate the question, environmentalists are concerned with the impact that dredging will have on the river.

When Henry David Thoreau first saw Bangor in 1846, he wrote, "There stands Bangor like a star on the edge of night, still hewing at the forests of which it is built." The history of the Bangor region is as long as the Penobscot River itself. In 1604, Samuel de Champlain was one of the first Europeans to sail up the river to present-day Bangor. The first sawmill was built in 1772, although the city wasn't incorporated until 1791.

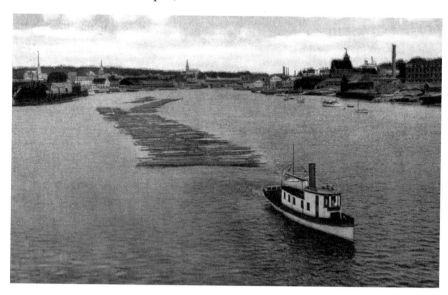

A log raft on the Penobscot River. In the nineteenth century, Bangor was the acknowledged lumber capital of the world. *Courtesy of the Bangor Public Library, Special Collections.*

The British returned to the Penobscot region during the latter stages of the War of 1812. Bangor was looted, and all but two ships were sunk in the harbor. Times change, however. By the 1840s, Bangor had become the acknowledged "Lumber Capital of the World." The city reached its peak in the 1870s—the so-called Golden Era. The waterfront was jammed with lumber, and the river was filled with as many as two hundred ships. On any given day from May to October, the Bangor harbor was so crowded with lumber coasters that it was possible to walk the 450 yards across the Penobscot River from Bangor to the town of Brewer on the decks of ships. Bangor's prosperity from the lumber industry began to fade in the late nineteenth century as the United States expanded to the Pacific and new timber stands were identified in Washington and Oregon.

Today, Bangor represents a contrast with the island and river communities to the south. The sawmills have disappeared as the lumber business moved west. The city of thirty thousand has changed its identity and become an important business, educational and historical center for northern and eastern Maine.

In the last few years, Bangor has also become a destination port for cruise ships, so harbor space is sometimes limited. I had made a reservation with the harbormaster for a berth at the town dock, so we were able to make it to my brother's house in time to celebrate his birthday.

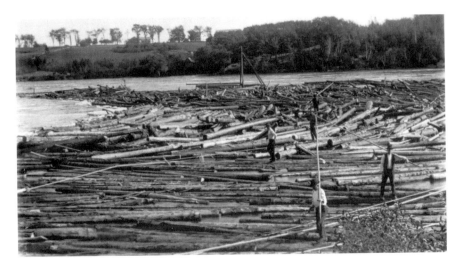

Log jam on the Penobscot River. Timber was floated downstream to one of the more than 250 sawmills on the river. From there the wood was loaded aboard ships to be carried around the world. *Courtesy of the Bangor Public Library, Special Collections.*

Return Trip

The first stop on our return to Vinalhaven was Fort Point State Park, located at the mouth of the Penobscot River. At Fort Point, a pier with a float extends two hundred feet into Fort Point Cove, providing access from the water. We spent an interesting hour walking around the park. In addition to hiking trails and picnic areas, the park includes the Fort Point Light Station and historic Fort Pownall, built by the English in 1759 as a protection from France during the French and Indian War.

Belfast is located in the northwestern corner of Penobscot Bay, a few miles from Searsport. It is a historic coastal town, though its origins are different from its neighbors. In 1770, when the first settlers arrived from Londonderry, New Hampshire, they had already secured title to the land and had it surveyed. Upon arrival, they cleared the land, and in the spirit of Athenian democracy, they drew lots to determine how the individual plots would be allocated.

Some of the original settlers wanted to name the new town Londonderry after their home in New Hampshire. One story is that a determined fellow from Belfast, Ireland, protested, and after a coin flip, Belfast won. Nine years later, the town was abandoned and burned when British forces invaded the area during the Penobscot Expedition in 1779. During the War of 1812, Belfast was again briefly occupied by the invading British.

People, Ports and Pastimes

During the middle and latter part of the nineteenth century, Belfast developed into a shipbuilding center, producing hundreds of medium-sized schooners, more suitable for coastal trade than trips around the world. As the town prospered, wealthy shipbuilders built the Federal, Greek Revival and Italianate mansions for which Belfast is still noted. In the twentieth century, the local economy shifted to harvesting seafood for the Boston and New York markets. Today, the town park overlooks an attractive harbor with good docking facilities, easily accessible by boat.

Islesboro and Warren Island

Paul Pendleton has lived on Islesboro his entire life, with the exception of the three years he was in the navy during World War II. Pendleton, now in his eighties, comes from an old island family. During the war, he was a radio operator on a destroyer escort. "It was brutal work," he recalls. "Crossing the Atlantic took twenty-one days. We could only go as fast as the slowest ship in the convoy."

Paul told me that in the 1760s the original settlers on Long Island, as Islesboro was called, were mostly fishermen and farmers. Later, shipbuilding became an important industry, including a major yard run by the Pendleton family. After the Civil War, summer residents from Bangor began to arrive. Then in the 1890s, "There was a building boom when rich folks began to build those big summer cottages around Dark Harbor," Pendleton said. Today, Islesboro's year-round population of 600 swells to 1,200 during the summer.

As we were driving around the island, Paul pointed to a roadside plaque that commemorates the first accurate observation of a solar eclipse in North America. This occurred on Islesboro in October 1780. Despite the fact that the American Revolution was raging, a team of intrepid Harvard scientists arrived determined not to miss out on this rare and important scientific event. Accordingly, they approached the British authorities and asked permission to set up their instruments. Permission was reluctantly granted, although they were told to "have no contact with the inhabitants." On the morning of October 27, the fog lifted and the scientists were able to set down detailed observations before departing.

Just off the west coast of Islesboro lies Warren Island, one of the best-kept secrets in Penobscot Bay. Warren Island has been a state park since 1959, when the Town of Islesboro gave it to the state. Warren Island is unique in that it was the first state park in Maine developed exclusively for boating enthusiasts. There are six courtesy moorings, a long pier, elegant campsites for tents, friendly rangers and beautiful walks on the seventy-acre island.

Left: Paul Pendleton, Islesboro historian and lifelong resident. *Photo by author.*

Below: The former Charles Dana Gibson summer cottage on Seven Hundred Acre Island, near Islesboro. Gibson was noted for his creation of the "Gibson Girl," an idealized representation of the American woman at the turn of the twentieth century. *Photo by author.*

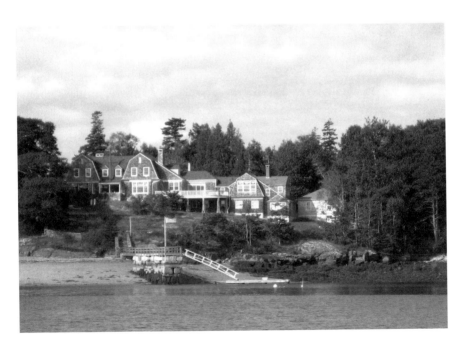

Warren Island public landing. Warren Island State Park was given to the state in 1959 by the Town of Islesboro. It is a pubic camping ground, accessible only by water. *Photo by author.*

The island is named for George Warren, who owned a house on the island in the nineteenth century. In 1899, William Folwell, a Philadelphia wool manufacturer, purchased the island and began construction of a two-story log cabin summer home, believed to be one of the largest and most expensive log cabins ever built in New England. The "cabin" was never used much by the family, and in July 1919, it burned to the ground. The remains of the foundation can be seen today in the middle of the island.

From Warren Island, we followed a well-marked channel past the town of Dark Harbor on Islesboro and headed southwest toward Crabtree Point on the west end of North Haven. With an outgoing tide and a following wind, we had a smooth passage back to our mooring on Vinalhaven, ending a truly historic trip.

PART II

SHIP STORIES

SUBMARINES IN THE BAY

One summer morning in the 1940s, Edith Quinn was washing dishes in her kitchen on Eagle Island. (Eagle Island is two miles northeast of North Haven and two miles west of Deer Island). Edith and her husband, Jim, had been living on Eagle since they were married in 1935. At one point, Edith looked out the window and, to her amazement, saw a submarine riding on the water a few hundred yards offshore. She called to Jim and they both rushed outside, where Jim quickly took the picture seen below.

Jim Quinn died thirty years ago, but ninety-eight-year-old Edith lives in the town of Sunset on nearby Deer Island, where she was recently awarded the *Boston Post* cane as the oldest person living on the island. When I spoke with Edith about the picture a few years ago, she recalled, "It was just sitting

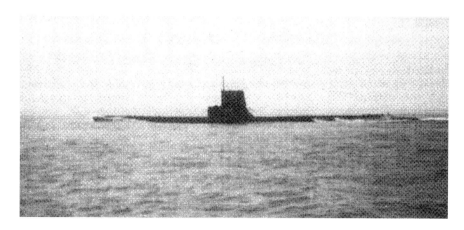

"Submarines in the Bay!" This picture was taken sometime in the 1940s. There is some question as to whether it is a German or American submarine. *Courtesy of Jim Quinn.*

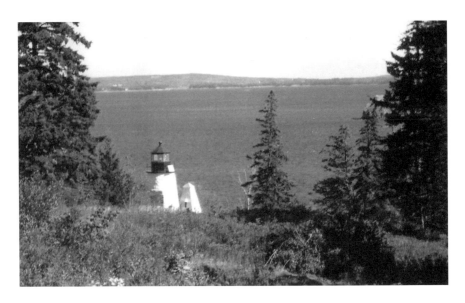

Looking northeast from the Eagle Island lighthouse. Seven generations of the Quinn family have lived on Eagle Island. *Photo by author.*

there. Shortly after we took the picture the sub began to move and suddenly it had submerged and was gone." It was well known that German submarines roamed the waters of the Gulf of Maine during the war. Was this a photo of a U-boat whose captain was determined to sink one more Allied ship before returning to his base in occupied France or Norway?

During the course of our conversation, I asked Edith if she had any recollection of when the picture was taken. Not surprisingly, she couldn't remember, except that it was during the summer. (When the Quinns' three children reached school age, they moved to Vinalhaven during the winter so their children could attend school.) A few years after the war, Edith's brother, John Beckman, gave this picture of the mystery sub to the Vinalhaven Historical Society.

As a longtime summer resident of Vinalhaven, I had heard stories about German U-boats operating in Penobscot Bay during the war. Since no one could remember the exact date of the picture, it was unclear whether the Quinns' photograph was of a German U-boat or an American submarine on patrol. John Beckman served on a naval repair ship in the Mediterranean during the war and feels that it was a U-boat. His logic was that most American subs were in the Pacific Ocean attacking Japanese shipping.

Identifying the mystery sub called for historical detective work. I faxed a copy of the Quinns' picture to Wendy Gulley, archivist at the Submarine

Force Museum in Groton, Connecticut. Wendy faxed me back an article by J.L. Christley (United States Navy, Retired) complete with illustrations. Close examination of the picture suggests that it is similar to the profile of a converted postwar GUPPY II submarine. The work on these submarines began in 1947 at the naval shipyard in Portsmouth, New Hampshire. In fact, the GUPPY program provided a link between World War II subs and nuclear submarines, the first of which, *Nautilus*, was launched in 1954.

So what was a GUPPY? GUPPY is an acronym for Greater Underwater Propulsion Power. In the years following the Second World War, the navy realized that a number of improvements needed to be made in its submarine force as the Cold War loomed. The GUPPY program took a number of late-model wartime subs that were in good condition and reconfigured them with an emphasis on more underwater speed and endurance. A streamlined hull and bridge, additional battery capacity and a snorkel breathing system characterized GUPPY subs. The deck gun, and all other external items that would increase underwater drag, were also removed. It is significant that there is no evidence of a deck gun in the Quinns' picture.

Sixty-five years after World War II, it is hard to be certain about all the facts connected with the boat in the picture. It is likely, however, that the submarine that Edith and Jim Quinn photographed that summer morning in the 1940s was a converted GUPPY II American submarine on its sea trials out of Portsmouth. If this is the case, it is difficult to see how the picture could have been taken before 1947.

Agent 146

If there is uncertainty connected with the identity of submarine in the Quinns' picture, there is less of a mystery about this next submarine tale. My father always loved a good story to tell his children. When he heard that German U-boats had been seen in Winter Harbor during the Second World War, he naturally assumed that the reference was to the Winter Harbor on the east side of Vinalhaven, just below Starboard Rock. The secluded, fjord-like harbor seemed a likely place for U-boats to surface and recharge their batteries. As children, we naturally accepted my father's view, ignoring the fact that the harbor was only 20 to 30 feet deep and too narrow for the maneuverings of a 175-foot U-boat. Recently, the reality of this submarine story was clarified.

Several years ago, a friend loaned me a book entitled *Agent 146* about two spies from Germany who were put ashore from a U-boat at Winter Harbor. This Winter Harbor, however, was Down East of Mt. Desert on the eastern

shore of Frenchman Bay. One of the spies, and the author of the book, was named Eric Gimpel. Gimpel's book, first published in 1957 and rereleased by St. Martin's Press in 2003, is an exciting story.

In 1935, Eric Gimpel was a twenty-five-year-old German working as a radio engineer in Peru when he was recruited by German intelligence. At first, he was merely asked to report on ships and cargoes leaving for English and French ports. In 1939, at the start of World War II, Gimpel returned to Germany, where he was formally trained in espionage. It was at that point that he became known as Agent 146. In 1943, he was told that he would be smuggled into America to blow up the Panama Canal. Gimpel recalls thinking, "Why not land on Mars, why not kidnap President Roosevelt?" Fortunately for Gimpel, the plan was called off at the last minute.

In July 1944, Gimpel was given another far-fetched assignment. In October, he and another spy were ferried across the Atlantic on sub *U-1230* (see the note at the end of this chapter). Their task was "to find out all they could" about the Manhattan Project (the atomic bomb). The crossing took forty-six days and was, as Gimpel recalls, "a tight fit in a sub with 240 tons of oil, 14 torpedoes, six months' supply of food and only two heads for a crew of 62 men." Nearing the coast of Maine, they got their bearings from the Mt. Desert Rock lighthouse, which conveniently remained lit. The U-boat captain, Hans Hilbig, decided that Frenchman Bay, east of Mt. Desert, was a good place for them to land. "Everywhere else he looked on their chart the water was too shallow." *U-1230* waited on the ocean floor until nightfall and then, as Gimpel writes, "We let the current carry us beneath the destroyer on patrol, into Frenchman Bay and up to Winter Harbor. We could hardly believe they didn't discover us…If the American coastal defenses hadn't been so asleep we would have been detected." Indeed, the Coast Guard was to answer for this later.

The two spies rowed ashore at Winter Harbor, just north of Schoodic Point, on November 29, 1944. An alert Boy Scout saw two "suspicious characters" walking along the road toward Ellsworth and reported them to the local authorities, but an amused local policeman ignored his message. The two men hitchhiked a ride to Bangor and then took the train to New York. From there, Gimpel had a series of adventures, culminating in his arrest in New York by the Federal Bureau of Investigation (FBI) late in December 1944. In fact, his fellow spy, a treasonous American who had lost his nerve, betrayed him. You will have to read the book for all the details, including those of his whirlwind romance with a beautiful New York woman who testified for him at his trial.

After his arrest, Gimpel was interrogated by the FBI and sentenced to death. In April 1945, the day before he was scheduled to be hanged, his

sentence was postponed during the period of mourning that followed the death of President Franklin Roosevelt. In September 1945, with the war over, President Truman commuted his sentence to life. Gimpel spent the next ten years in various American prisons, including three at Alcatraz. In 1955, he was paroled and sent back to Germany, where he wrote a book about his adventures, including his landing at Winter Harbor.

After dropping its passengers, U-1230 *resumed its war patrol and sank the Canadian steamer* Cornwallis *(5,458 tons) on December 3, 1944. It then returned to its base in Kristiansand, Norway. Following the surrender of Germany in May 1945,* U-1230 *was transferred to Lock Ryan, Scotland, where it and a number of other U-boats were sunk by gunfire from the British frigate HMS* Cubitt.

MONHEGAN'S VENERABLE *LAURA B* TURNS SIXTY-FIVE

At the end of World War II, a battered U.S. Army workboat was found on one of the Solomon Islands in the Pacific with its wheelhouse blown off. Because of its rugged hull, however, it was considered worth saving. *T-57,* as it was known then, was loaded on a Liberty ship and, along with five other T-boats, was returned to the M.M. Davis yard in Solomons, Maryland, where it had been built sixty-five years ago, in 1943.

In 1946, Clyde Bickford, an enterprising Vinalhaven lobsterman, visited the Maryland yard. The first thing he saw was a vast store of surplus war equipment being consumed by a huge bonfire. In what was literally a "fire sale," Clyde purchased *T-57* for $6,500 before it could be added to the flames. He named it *Laura B,* after his mother, Laura Bickford.

Clyde's next stop was a boatyard in Camden, where he engaged Horace Ledbetter to rebuild *Laura B* for use as a lobster smack. During the reconstruction, Ledbetter discovered further evidence of wartime action, when crudely patched bullet holes were found in the bulwarks.

For the next seven years, Clyde and his brother-in-law, Luther Burns, used the sixty-five-foot, eighty-ton vessel to transport lobsters from Vinalhaven and other islands to Boston and the Fulton Fish Market in New York City. Clyde's nephew, John Bickford, worked on it as a boy, making local trips to Rockland, and recalls, "She was a good rugged boat." Even then, *Laura B* was an all-purpose boat. Paul Chillis remembers, "We took her to high school ball games on the mainland." In 1952, however, after a particularly violent nor'easter, Clyde sold it to Earl Fields, who ran the Monhegan Boat Line.

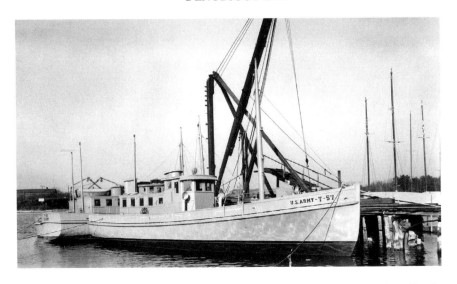

T-57 was found on a Pacific island at the end of World War II. It was renamed *Laura B* and became the Monhegan ferryboat in 1954. *Courtesy of the Calvert Marine Museum, Solomons, Maryland.*

The T-boat designation stood for "tender." It might also stand for "tough," since the boats were designated as transport/tugs for use in both the Atlantic and Pacific campaigns. Essentially a heavy-duty workboat, *T-57* was used to haul cargo and transport personnel ashore from larger ships. In addition to possessing a large hold, *T-57* was well armed. With a crew of fifteen, it mounted a pair of fifty-caliber machine guns forward and a twenty-milimeter Bofors gun aft. Several times during its Pacific travels, it came under enemy fire. The last attack, on the Solomon Islands, resulted in the destruction of its wheelhouse.

Approximately 170 T-boats were built during the war, 48 by the Davis yard in Solomons, Maryland. *Laura B* is one of just three documented T-boats that remain in service on the East Coast (the others, *Sgt. Jones* in Northport, New York, and *Chappie IV* in Wanchese, North Carolina, are both registered for commercial fishing purposes). There is a fourth T-boat, *Niad II*, that is still in service on the West Coast. *Niad II* has been a fire patrol boat and a police patrol boat in the Seattle area. Later, it took charters north to Alaska. For twenty-two years, *Niad II* was a beloved yacht/home for its owners until it was recently sold as a pleasure craft to a family near Vancover, British Columbia, for $40,000.

Having just had its sixty-fifth birthday, it was launched on December 15, 1943. *Laura B* can look back on a long and varied career. It has made the

ten-mile run between Port Clyde and Monhegan Island since 1954. In the process, it has hauled trash, trucks and troops (if you count World War II), as well as luggage, lumber and lobsters. *Laura B* has carried thousands of passengers, assorted animals—including a 350-pound sow—and even a couple of pianos. It is a mail boat and a rescue boat, and it does charters. In addition, in the summer it takes tourists to see the puffins on Eastern Egg Rock and to visit nearby lighthouses. *Laura B* is an all-purpose craft if there ever was one.

In 1976, the present owner, Jim Barstow, bought the Monhegan Boat Line business, including *Laura B*, for $80,000. At the same time, he leased a dock and ticket office in Port Clyde, which he has since purchased outright. In 1995, *Elizabeth Ann* was bought for the primary purpose of transporting people, which gives the line additional flexibility. In the summer, *Laura B* carries mostly freight and *Elizabeth Ann* exclusively passengers. In the off-season, when one boat is laid up for maintenance, the other continues to supply the island.

Not long ago, a prominent marine surveyor described *Laura B* as the "finest-maintained wooden vessel on the eastern seaboard." This is no accident. An article in *Wooden Boat* magazine entitled "The Care of *Laura B*" emphasized that "the vessel is cared for with thoughtful precision and nearly

Jim Barstow, Monhegan Boat Line owner and captain of the *Laura B*. *Courtesy of Monhegan Boat Line.*

boundless energy by her captain and crew." As a former captain, Alan Lord explained, "We are always poking around, cleaning and scraping. We don't give this vessel a chance to rot."

After years of having it serviced at the Billings yard in Stonington, the crew of *Laura B* now does most of their own maintenance. It is taken out of service every spring and fall, steam cleaned and carefully inspected. Depending on what is needed, the attention differs each time—the hull, the engine or the electrical system. In fact, the crew probably spends as much time caring for the old wooden boat as they do running it.

Laura B's sixty-fifth birthday was celebrated on July 20, 2008, as part of the St. Georges Day festivities. Activities included fireworks, a parade and afternoon tours of Port Clyde Harbor on *Laura B.*

REMEMBERING THE MAINERS
ONBOARD THE USS *MAINE*

On February 15, 1898, the battleship USS *Maine* was sunk in the Havana harbor. The ship had been sent to Cuba to protect American interests during a period of intense local unrest against the Spanish government on the island.

Most of the 266 men who died were crew members, sleeping or resting in the forward part of the ship at the time of the explosion, which occurred at 9:40 p.m. Ironically, taps had been played at 9:10 p.m. Officers were quartered aft, and most, including the captain, were ashore. Only two officers died in the explosion.

Of the eight young men from the state of Maine onboard, six died in the mysterous explosion that sank the ship 110 years ago. One casualty was a twenty-year-old apprentice seaman from Bath; another was a fireman first class from Portland.

More than a century later, the cause of the explosion continues to generate controversy. Was it internal combustion from the coalbunker located next to the powder magazine, or was a mine detonated outside of the ship's hull? Whatever the cause, the explosion of five tons of powder in the magazine virtually obliterated the forward third of the ship.

Not surprisingly, the event was widely publicized by the American press, which inflamed public opinion, contributing to the outbreak of the Spanish-American War. What the history books don't give us is much information about the crew. Where were they from? *Maine*'s company of 350 men came from twenty-three states and fifteen countries. Twenty-two sailors were African American.

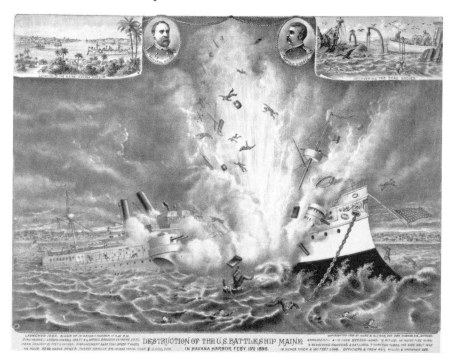

The destruction of the battleship *Maine* in Havana Harbor on February 15, 1898. At least 266 men died in the explosion, including 6 sailors from Maine. *Courtesy of the Library of Congress, Prints and Photographs Division.*

Who were the casualties from Maine? The *Bath Daily Times* informs us that there were two "Boys from Bath" on the doomed ship, John Sweeney and Frank Talbot. Sweeney worked in the boiler shop at the Bath Iron Works for ten years and left in 1897 to join the ship. For some reason, he was not listed on the ship's roster and thus was not initially reported as dead. A third casualty, Clarence Lowell, was born in Bath, but the *Times* observed, "When he was a lad his father moved to Augusta."

Twenty-year-old Frank Talbot's story is especially poignant. The *Bath Daily Times* reports, "He completed his studies at the Lower Grammar School before working in Shaw & Sons mill. He was a bright boy and much liked by his friends." Talbot came from a seafaring family. His grandfather was in the navy for twenty years, and his father spent three years at sea during the Civil War.

Talbot joined USS *Maine* on December 26, 1897, as an apprentice seaman, having trained for a month on *Wabash* in Charlestown, Massachusetts. His last letter home was written the night before USS *Maine* left Key West for Havana and indicated that he was enjoying his work very much. "I would like to come home this spring, but I can't tell when I will get north again. We

leave tomorrow for Havana. Good-bye. Your loving son." On February 22, the *Times* reported that Talbot's parents "have not received any news and that Mrs. Talbot is nearly crazy with grief." Another casualty, Millard Harris from Boothbay, was listed on the ship's roll as a quartermaster, third class. Harris, forty-eight, had a wife, Agnes, and is listed as a "ship master" before the war. No other information for him is available.

Three men—Bernard Lynch, William H. Tinsman and John H. Bloomer—were from the Portland area. The first two died in the explosion. All we know about Lynch is that he was a fireman first class on the battleship. Tinsman, who enlisted in 1897, also came from a seafaring family—his father, William H.H. Tinsman, served on USS *Merrimac* during the Civil War. Tinsman was born in Pennsylvania but grew up in East Deeering. He was also listed as a landsman (apprentice seaman) on the battleship.

Who survived? John Bloomer and Martin Webber survived the explosion, although both men were injured. Bloomer was a member of the ship's baseball team and, with the exception of the goat shown in the team picture, was the only member of the squad to come out alive.

In the late nineteenth century, every ship in the navy had a baseball team, and USS *Maine* was no exception. Just before the ship left for Cuba, this photo of the team was taken in Key West, Florida. This proud but ultimately tragic assemblage of players, coaches and goat mascot had recently beaten a team from USS *Marblehead* by a score of 18–3 to win the navy championship. *Maine*'s star player was a left-handed African American pitcher named William Lambert (upper right in the photograph). Lambert was an engine stoker from Virginia who was described by a teammate as "a master of speed, curves and control."

Bloomer returned to Portland after the war, where he worked as a stevedore in the summer and a trucker in the winter. He died in 1907 at the age of thirty-five from "a complication of diseases attributed to his experience in the disaster," according to his obituary. Bloomer was survived by a wife and three children and is buried in South Portland.

The eighth sailor from Maine, and the only other survivor besides Bloomer, was Martin Webber from Bar Harbor. Webber was listed as a "landsman" on the ship's roster and, as noted, was injured in the explosion. Webber died in 1952 at the age of seventy-five. His death certificate lists him as a retired truck driver. Other than this, and the fact that his wife's name was Rose, we know nothing more about the last fifty-four years of his life. Webber is buried in the Holy Redeemer cemetery in Bar Harbor.

The wreckage of USS *Maine* remained in the Havana harbor for the next fourteen years. The ship's tangled superstructure was clearly visible in the

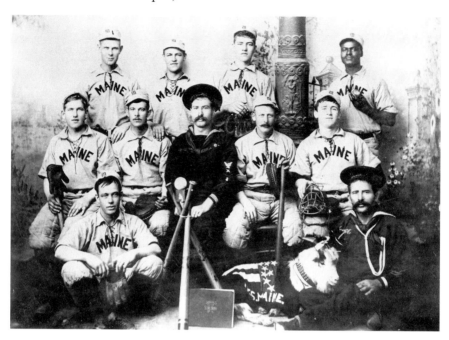

The battleship *Maine*'s baseball team after winning the Navy Baseball Championship. All members of the team were killed, except the goat and J.H. Bloomer of Portland, Maine, upper left. *Courtesy of the Library of Congress, Prints and Photographs Division.*

shallow waters while three inclusive inquiries were conducted into the causes of the explosion. In 1912, USS *Maine* was raised for its final voyage. It was towed three miles out to sea and sunk for the last time in four thousand feet of water.

RENDEZVOUS: THE LAST LIBERTY LAUNCH?

Rendezvous is easy on the eye. The elegant vessel sits quietly at its berth at the Maine Boats, Homes and Harbors dock in Rockland, awaiting the next group of sightseers to come aboard. Underway, *Rendezvous* maneuvers gracefully around the harbor, a striking contrast to most of the vessels around it. With a cruising speed of seven knots, the stylish craft is a sedate and very senior member of the Rockland boat community.

Rendezvous is not a fishing boat, nor is it a sailboat. *Rendezvous* is a former World War II Liberty Launch originally built to shuttle soldiers and sailors ashore for leave. With mahogany decking laid over an oak hull, and the original 671 Detroit diesel engine below its decks, *Rendezvous* is truly an heirloom.

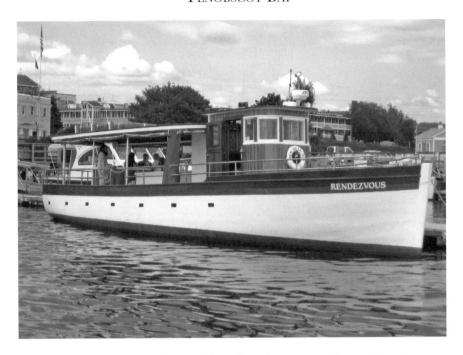

Rendezvous as seen in Rockland Harbor. Liberty Launches were used for a variety of purposes during World War II, including transporting troops from ship to shore. *Photo by author.*

When it was built sixty-five years ago, *Rendezvous* was a fifty-one-foot craft with a thirteen-foot beam, operated by a crew of up to four men (the coxswain steered from a tiller at the stern in those days). A Liberty Launch like *Rendezvous* was rated by the navy to carry up to 150 passengers. In reality, this meant taking a boat filled with enthusiastic young men several miles from their deep-draft ship to shore. To give you an idea of how crowded it must have been, the maximum number of passengers allowed on its harbor cruises these days is 36!

Imagine, for a minute, what it was like to be aboard such a launch heading toward a liberty port during the Second World War. (The present captain admits that *Rendezvous* is not a particularly seaworthy boat in swells of more than two feet.) Dozens of men were crammed together like sardines and soaked with spray after the first minute or two. "There were only two ways to get to and from the beach," a Liberty Launch vet recalls. "Liberty Launch and water taxi transport was damned expensive." The return trip must have been even more exciting. The same sailor remembers, "We were a happy, rollicking load of bluejackets. Singing songs that our mother would have shot us for. Laughing like deranged lunatics. Damn, it was fun."

At the height of World War II, the navy constructed thousands of these diesel-powered crafts for a variety of functions. In addition to providing transportation ashore, they ferried supplies back and forth to big ships. Large vessels such as battleships and aircraft carriers used them as lifeboats. On other occasions, they were used by meteorologists and oceanographers for surveying coastal areas, where deeper draft ships could not venture.

Like another World War II vessel, the venerable Monhegan ferryboat *Laura B*, *Rendezvous* was built in 1943, which means that it had its sixty-fifth birthday in 2008. Unlike *Laura B*, however, we know very little of *Rendezvous'* early history. We do know that it was built in a naval shipyard in Portsmouth, Virginia, and that *Rendezvous* was not its original name. Presumably, the navy assigned it a specific number. Whether it served in the Atlantic, Pacific or Mediterranean theatres is not known.

After the war, Liberty Launches were so common that they were scrapped or allowed to deteriorate, since they were made of wood. The navy sold a few to private owners for commercial purposes or use as excursion boats. Boats surviving the scrap heap, however, required regular maintenance. The *Rendezvous*, then, is a rare find. It is one of the very few that remain from the thousands that were built sixty-five years ago. A recent owner, Steve Pagels of Bar Harbor, thinks he may have seen one "a long time ago" in Wilmington, North Carolina.

Rendezvous' registration number first appears on Coast Guard records on December 31, 1952, when it was nine years old. On that date, it was sold as surplus by the navy and became an officially documented passenger vessel. We do not know who were its owners during these years, since the name *Rendezvous* does not appear on its registration form until May 12, 1975. We do know that it was fitted out with a pilothouse and a canopy covering the stern area, and that it was run as an excursion boat in Boston Harbor and, later, the Marblehead area.

Rendezvous' next move was to New York State in 1998. Its new owner was Gary Smith, who lived in Haverstraw, New York. (Haverstraw is approximately thirty miles up the Hudson River from New York City.) Smith intended to use it as an excursion vessel on the Hudson, using Haverstraw as his homeport. Unfortunately, the new owner became seriously ill before he was able to fully restore the boat and carry out his scheme. As a result, *Rendezvous* languished in a Haverstraw, New York boatyard for the next six years.

In 2004, *Rendezvous* was "rescued" by Steve Pagels, who purchased it from Smith for $25,000. Pagels brought the boat to Bar Harbor with the idea of using *Rendezvous* as backup vessel for his ferry service from Bar Harbor to Winter Harbor (across Frenchman Bay) and for excursions and charters to

nearby islands. Pagels found, however, that *Rendezvous* lacked maneuverability and that its cruising speed of seven or eight knots was not fast enough to keep to a regular ferry schedule. The result was that *Rendezvous* was taken out of service and put on the market.

In the fall of 2007, *Rendezvous* was purchased by its present owner, Brenda Walker Thomas, who saw it sitting in the Hinkley boatyard in South West Harbor on Mt. Desert. After buying the boat, Brenda and her husband, Brian, decided to use it to take tours around Rockland Harbor and for excursions to some of the nearby offshore islands.

The winter of 2007–8 was spent on extensive (and expensive) restoration of *Rendezvous*. First, it was stripped down to essentials. Not surprisingly, a lot of rot was found, though the hull and frame were structurally sound. The pilothouse and canopy were replaced, and layers of paint, plywood and fiberglass were painstakingly stripped off. Next, it had to be brought up to code for commercial use. As one crewmember put it, "There were lots of hoops to jump through."

Shortly after *Rendezvous* was launched in May 2008, disaster struck in the form of a large fishing trawler that hit it in the middle of the night as the trawler was backing away from the nearby Rockland public landing. Once again, *Rendezvous* had to be hauled out of the water and repaired to the tune of $15,000.

When I saw *Rendezvous* late in the summer of 2008, it was back to normal operation, sitting at its berth in Rockland Harbor, awaiting passengers for one of its scheduled tours. The captain told me that the tours are flexible, and they tailor their trips depending on who the passengers are. Underway, he may talk about the construction of the Rockland breakwater or tell a tale about one of the many windjammers frequently seen in the harbor. If there are kids onboard, he might talk about the Owls Head Lighthouse ghost.

The ghost story stems from the days when the lighthouse was heated with oil and also burned oil for the light itself. In recent years, people who have spent the night in the lighthouse have often said that they have felt a strange presence. Sometimes they wake, chilled, in the middle of the night and find that the heat has gone way down and the furniture has been moved around. The story goes that the spirit of one of the old lighthouse keepers has returned and turned down the heat to conserve oil for the light.

If you take a ride on *Rendezvous*, think about its history. What oceans has it crossed and what coastlines has it explored? How many rowdy sailors has it transported back to their ships? How did it survive the scrap heap once the war was over, and who has owned it since then? Is *Rendezvous* really the last of the Liberty Launches?

PART III

MAINERS IN WAR AND PEACE

GENERAL HENRY KNOX, MAINE'S FORGOTTEN FOUNDING FATHER

Henry Knox led three lives. He was a soldier, a statesman and a landed entrepreneur. During the Revolution, Knox was closer to Washington than any man except Lafayette. And yet this giant of a man (six feet, two inches tall and 280 pounds) is one of our least-known Founding Fathers.

Eighty years ago, the General Knox chapter of the Daughters of the American Revolution in Thomaston, Maine, decided to do something about reviving the memory of Henry Knox. A drive was launched to rebuild Montpelier, the Knox family home demolished in 1871. The building opened in 1931.

Knox had a difficult childhood. His father deserted the family when Henry was nine, and he was sent to work as an errand boy in a Boston bookstore to help support the family. During these years, Knox led a double life. He joined a gang and gained a reputation as the toughest guy in the neighborhood. At the same time, the bookstore offered him a sanctuary where he could continue his education by reading voraciously, especially books on military history. When he was eighteen, he joined a local militia company and his life as a soldier began.

At the start of the Revolution, twenty-five-year-old Henry Knox was ordered by George Washington to transport sixty tons of artillery from recently captured Fort Ticonderoga, on Lake Champlain, to Boston, more than three hundred miles away. In less than two months' time, Knox and his men performed the incredible feat of moving fifty-nine pieces of artillery across lakes and rivers, through ice and snow, to Boston.

When they arrived in early March, Knox maneuvered the guns to a hill overlooking the city. The next morning, an astonished British commander, General Howe, looked up at the Dorchester Heights and remarked, "The

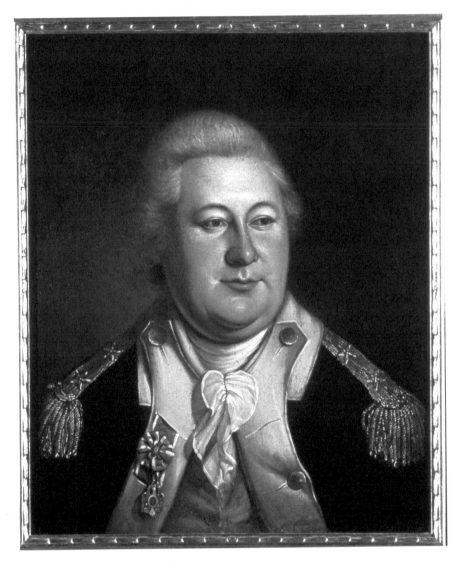

Henry Knox, General Washington's general. Painting by Charles Willson Peale, circa 1784. Knox founded the Society of Cincinnatus and is wearing its medal. *Courtesy of Independence National Historical Park.*

rebels did more in one night than my whole army would have done in one month." Ten days later, the British evacuated Boston, giving George Washington his first victory of the Revolutionary War.

Promoted to general by a grateful Congress, Knox became known as "General Washington's General." He was at Washington's side throughout the Revolutionary War, from the siege of Boston in 1775 to the British

surrender at Yorktown in 1781. Although he is regarded as the "Father of American artillery," Knox remarkably had no formal training as an artillery officer. Everything he learned came from books, starting back in that Boston bookstore.

For a self-made man, the list of Knox's achievements is stunning. Following the Revolution, he was appointed secretary of war during the Articles of Confederation period (1781–88). Knox soon realized, however, that this arrangement was not working. Accordingly, he proposed plans for a federal government that was amazingly prescient in anticipating the United States Constitution.

When Washington was elected president, Knox was our first secretary of war from 1789 to 1794. Some of his accomplishments included: reorganizing the army, creating a regular navy, constructing coastal forts, planning a military academy at West Point and negotiating a treaty with Indian tribes.

The latter is the action for which Knox has received perhaps the least recognition. As secretary of war under Washington, he argued "that the independent tribes of Indians ought to be considered as foreign nations not subjects of any particular state." Historian Joseph Ellis wrote recently in *American Creation* that Knox was attempting nothing less than "a wholesale reversal of the American Indian policy." With Washington's approval, Knox made a genuine effort to establish a policy that would permit Native Americans to maintain their sovereignty. Sadly, we know how the story ended—with waves of eager settlers ignoring the treaty and pouring into the newly designated Indian lands.

The Maine Connection

What, then, was Knox's involvement with Maine (a district of Massachusetts until 1820)? Knox claimed his Maine lands through his wife, Lucy Flucker, who inherited a portion of the vast "Waldo Patent" from her mother, who fled to England with her Tory husband at the start of the American Revolution. The huge tract, located between the Kennebec and Penobscot Rivers, had been given to Lucy's maternal grandfather, Samuel Waldo, by the British for his services in the French and Indian War.

After serving as secretary of war for ten years in two governments, Knox resigned in December 1794 to concentrate on consolidating his control of the Waldo Patent, confiscated during the Revolution. Through his political connections in Massachusetts, Knox had ended up purchasing most of the original patent at well below market price. Squatters on his lands were evicted, and the resources of Maine were exploited, as Knox launched

ambitious programs in farming, blacksmithing, granite cutting, lumbering, lime burning, salt making and shipbuilding.

He opened a store and built a wharf, sawmills, locks and a canal on the St. Georges River. He sold land to settlers and laid out roads, including one from Belfast to Augusta. One of his biographers, North Callahan, wrote, "He was like the man who mounted his horse and rode off in all directions at once. He planned more in a day than could be executed in a year."

Knox certainly generated controversy. Many saw him as a ruthless land baron and were unhappy with his and his wife Lucy's grand lifestyle. This included Montpelier, an elegant twelve-thousand-square-foot, twenty-four-room mansion in Thomaston that rivaled any private building in North America. Critics described it as "the seat of a prince with an extensive establishment."

Henry Knox died suddenly in 1806 at fifty-six from an infection caused by a chicken bone that stuck in his throat. With no associate or family member possessing his energy or vision, the promising business enterprises of this giant man collapsed. Recent biographer Mark Puls wrote, "A remarkable life had come to an unexpected, sudden close."

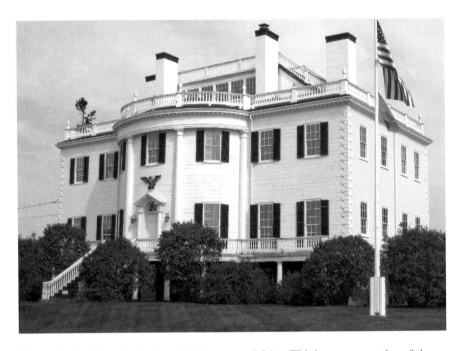

Montpelier, the Knox family home in Thomaston, Maine. This is a reconstruction of the original building. It was opened in 1931. *Photo by author.*

There are two memorial sites dedicated to Knox in Maine. The first is Montpelier, the rebuilt family home and today a museum. The other, the *first* Fort Knox, sits at the narrows of the Penobscot River, opposite Bucksport. It was begun in 1844, during a period of tensions with Great Britain over Canadian boundary issues. Today, it is the most popular historic site in the state, attracting over 100,000 visitors a year. Of course, the "other" Fort Knox sits on 110,000 acres in Kentucky, houses most of the nation's gold reserves and serves as a training center for the Tank Corps.

Henry Knox was certainly no saint, but one cannot deny his incredible energy or his service to his country. In addition to Montpelier and the two forts that bear his name, there are nine counties named after him in as many states, as well as towns named Knoxville in Alabama, Georgia, Illinois, Iowa, Nebraska and Tennessee. There is a Knox Artillery Medal and a Knox Hall at Fort Sill, Oklahoma, home of the Field Artillery Center. Major General Henry Knox died over two hundred years ago. Perhaps he is not quite such a forgotten Founding Father after all.

LEST WE FORGET: VINALHAVEN GOES TO WAR

In December 1944, First Lieutenant Phil Brown (Vinalhaven High School class of 1939) found himself and his radioman pinned down by German shells at the height of the Battle of the Bulge. Brown recalls hearing an incoming shell "that had our names on it." "So long kid," he called to the radio operator. "So long Lieutenant," was the reply. Then the shell hit, destroying a tree between the two men yet miraculously failing to explode. When demolition experts later examined the dud, it was found to be stuffed with enough sawdust to stop the detonation. Inside it, a note was found written in English but in the style used by Europeans, saying, "We Hope This Can Help You To Live." As Brown said in an interview after the war, "I owe my life to some poor human being in one of those slave labor camps."

Not everyone was as fortunate as Lieutenant Brown and his radioman. Sixteen of the more than three hundred young men and women from Vinalhaven who served died in the war. Their names, along with all of those who fought in America's wars, are read annually during the Memorial Day parade. Beginning at the American Legion Hall, the parade proceeds through the town to the Civil War monument across from the library. The band plays, prayers are recited and the names are read.

Burke Lynch served in the Marine Corps for twenty-two years before retiring in 1988 to live on Vinalhaven. Over the years, Burke, a Vietnam

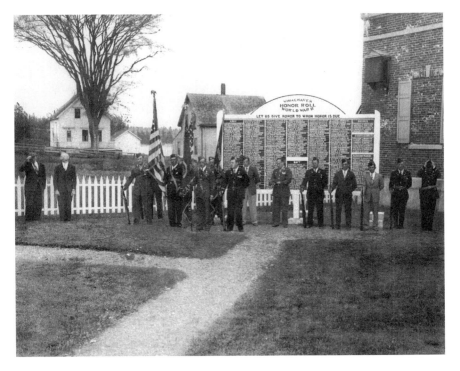

Salute to the honor roll on Memorial Day, 1940s. The names of all island residents who have fought in American's wars are read annually. *Courtesy of the Vinalhaven Historical Society.*

veteran, has taken part in many Memorial Day parades, and yet he says, "I have never seen anything like the one on Vinalhaven. I consider it a privilege to participate."

Previous Wars

The record shows that Vinalhaven islanders have traditionally supported their country in times of war. Exactly 123 men from Vinalhaven fought for the Union during the Civil War. Of these, twenty three, including a sixteen-year-old and a seventeen-year-old, "Gave their Lives in Defense of Their Country During the Great Rebellion." This very inscription and the names of those who died are engraved on an impressive monument at the end of Main Street. Records in the Vinalhaven Historical Society indicate that more deaths occurred as a result of infection or disease than from wounds on the battlefield.

Lafayette Carver and Woster S. Vinal were among the several Vinalhaven men who fought at the Battle of Gettysburg in 1863. Both men survived the

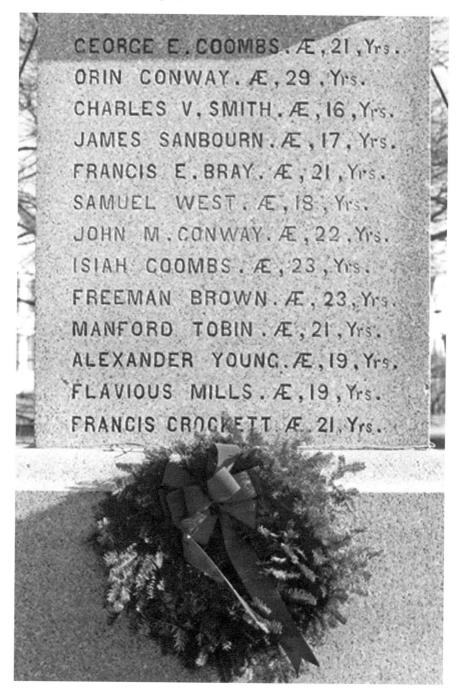

The Civil War monument. During the war, 123 men fought for the Union, 23 of whom died, including a sixteen-year-old and a seventeen-year-old. *Photo by author.*

battle, though Lieutenant Carver died of a wound he received two years later at the Battle of Cold Harbor. Woster Vinal was captured, survived the notorious Andersonville Prison and returned home to Vinalhaven. Vinal lived to age ninety-three, the last Civil War veteran from the island to die.

In 1917–18, seventy men from Vinalhaven fought in American's brief participation in World War I. Of these, two soldiers, Elmer Noyes and Robert Cassie, received the prestigious French award, the *Croix de Guerre*, for services rendered in the line of duty. Noyes spent a year on active duty in France. According to a *Rockland Courier-Gazette* clipping, "He has seen and lived through the grimmest side of the war. He is not permitted to state for what reasons the citation was made but it is understood that it was for volunteering to accept dangerous duty during the recent March offensive." Robert Cassie was in the field artillery, and as in the Noyes case, no mention was made of the "courageous act Mr. Cassie may have performed to win the citation," the paper reported.

Vinalhaven is by no means the only Penobscot Bay island to have supported America's wars. North Haven has records showing that over 200 men have fought in America's wars, beginning with the 24 who fought in the Revolution and up to the 29 who served in Vietnam. And Islesboro has sent more than 250 men to fight for their country, including 55 in the Civil War, 50 in World War I, 98 in World War II and 39 in Korea.

From Depression to War

Like most communities across America in 1940, Vinalhaven was still feeling the effects of the Great Depression. According to a recent census, the population of the island had declined from a high of almost 3,000 people in 1880 (when the granite business was at its height) to 1,630 year-round residents in 1940. There simply wasn't much money to be made. Most of the quarries had closed down, and lobsters were selling for six cents a pound. Across the bay in Rockland, many businesses were boarded up and homes were neglected. Few houses had refrigerators and fewer than half had indoor plumbing. A newcomer to the town recalled, "Coming to Rockland in 1940 was like stepping back fifty years into history."

The reality of the war in Europe, which had begun in 1939, was brought home to Vinalhaven when President Roosevelt visited Rockland on August 16, 1940. This followed his historic Atlantic Charter meeting with British prime minister Winston Churchill off the coast of Newfoundland. Sixteen months later, America was at war with both Germany and Japan following the December 7, 1941 attack on Pearl Harbor. As the threat of war drew

closer, many Vinalhaven families left the island for better-paying jobs on the mainland in the defense industry. The Vinalhaven Historical Society contains a list of twenty-seven men and women who went to work for Pratt and Whitney in Hartford, Connecticut. Buddy Skoog (VHS '46) recalls his family moving to Rhode Island, where his father worked in naval shipyards. In 1942, Buddy persuaded his parents to let him return to the island to attend high school.

War first came to Vinalhaven in the form of German submarines. On Christmas Eve 1941, island residents heard heavy gunfire southeast of the island. Authorities refused to comment, and government censorship soon prevented such reports from even appearing in the press. In 1942, Fred Tripp, lobstering off Matinicus, recalled listening to U-boats at night charging their batteries, and he often heard bits of German drifting over the water in the darkness. The Coast Guard issued shortwave radios to lobstermen working off the outer islands of Penobscot Bay so they could report suspicious activities. Phil Dyer tells the story of a lifeboat riddled with bullet holes that was found on the eastern shore of Vinalhaven. One theory was that the boat was from a sunken merchant ship and that a submarine crew shot up its occupants.

Submarines continued to be sighted off the East Coast throughout the war, and residents of island communities were advised to keep a sharp lookout for good reason.

Shortly after the United States' entry into the war, Hitler ordered an extensive sabotage campaign designed to disrupt American industry. As early as June 1942, German saboteurs were arrested, which increased tensions up and down the coast. On Vinalhaven, a watchtower was built above Carver's Harbor on Ambrust Hill, with a direct phone line to Bangor to report "suspicious activities." Townspeople manned the tower around the clock, women during the day and men at night. Residents remember the boxlike structure being very cramped and very cold in winter. At one point, Virginia Webster spotted "a black shape low in the water," which she called in, giving its approximate distance and direction. She found out later that the suspicious object was nothing more than an oil boat laden with fuel. And then there was Vinalhaven's Roy Ames, who kept homing pigeons on his boat. They were trained to head for designated places on the mainland as a part of the coastal alert system. Later, Roy received a thank-you from the government for his assistance.

The war affected life on Vinalhaven in a variety of ways. Blackouts were enforced at night, and wardens patrolled the town to ensure compliance. Windows had to be completely darkened, and the few cars on the island were

instructed to use only their parking lights when out at night. Gas, sugar, meat and rubber were just a few of the items rationed. Buddy Skoog, who had returned to the island for high school, recalls that most families had gardens, kept a few chickens and often did a bit of hunting. Phil Dyer remembers Coast Guard ships arriving at Carver's Harbor with extra gas. Enterprising sailors would "exchange" gas for lobsters with local fishermen, boosting the local economy a bit.

In 1942, the island ferry *W.S. White* was commandeered by the army to transport troops in Portland Harbor, leaving Vinalhaven (and North Haven) cut off from the mainland. For a year, Captain Charlie Philbook filled in as best he could with his forty-foot fishing boat until the *Vinalhaven II* began service in July 1943. Throughout the war, nearby Seal Island was used by the navy for target practice. Buddy Skoog remembers sitting in school, feeling the walls vibrate and watching shells and bombs hitting the island five miles away. One afternoon, Phil Dyer and his brother, Joe, were fishing off Seal Island. To their horror, several destroyers suddenly appeared and commenced target practice before they could get out of the area. The boys returned to Vinalhaven with shells flying over their heads for the first part of the trip. Today, Seal Island is a bird sanctuary that still contains rounds of live ammunition.

Stories to Tell

Many of the young men on the island chose to enlist in a particular branch of the service to avoid being drafted into the army. John Beckman and his younger brother, Francis, both enlisted in the Marine Corps in 1942. Unfortunately, Francis was one of the twelve thousand Americans killed in the brutal battle for Okinawa in 1945.

John Beckman survived the bloody Anzio landings in Italy early in 1944. A few months later, he found himself on a ship headed for the invasion of France. For some reason that has always puzzled him, he was ordered off the ship and, as a result, missed the D-Day landings of Normandy. He later heard that his section of the ship sustained a direct hit by a German shell and that fifty of his crewmates were killed. After the war, John Beckman returned to his beloved island and spent the next sixty years of his life lobstering and building boats. Today, in his late eighties, he still lives on Vinalhaven, where he enjoys talking with his friends and recounting his war experiences.

Arnold Barton and his cousin, Fred, both joined the navy in January 1944. After six weeks' training in boot camp, twenty-one-year-old Fred Barton was sent directly overseas. He was killed at the height of the D-Day

landings when the minesweeper he was on sustained a direct hit from a German shore battery. Arnold Barton served on a tanker in the Atlantic and a repair ship in the Pacific until the end of the war. After the surrender of Japan, he returned to Vinalhaven and resumed his life as a lobsterman and fisherman. "His life pretty much returned to normal as he took up fishing and caretaking," recalled his wife, Charlotte. As he got older, he enjoyed talking about his wartime experiences with his family and friends.

Allan Middleton (VHS '34) was president of his class and a high school pitcher good enough to be signed by the Boston Red Sox, although he never made it to the Major Leagues. Middleton joined the air force shortly after Pearl Harbor, and in 1942, he was assigned to the Ninety-first Fighter Squadron based in North Africa. On January 27, 1943, Middleton was killed when his plane was shot down over the Mediterranean Sea. His body was never found.

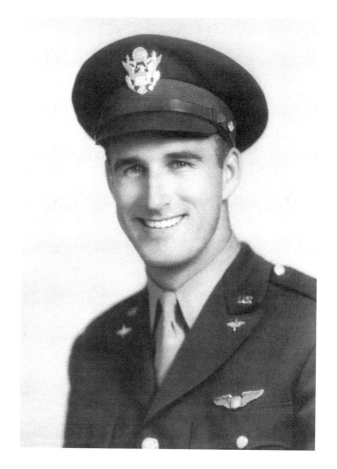

Allan H. Middleton. He was the first islander to be killed in the Second World War when his plane was shot down over the Mediterranean Sea in 1943. *Courtesy of the Vinalhaven Historical Society.*

Following his extraordinary escape from death in the Battle of the Bulge, Phil Brown returned from Europe, having won three Bronze Stars. At Dartmouth College, he resumed his studies, which had been interrupted by the war. Brown completed his degree in 1946 and decided to pursue a career in business, though friends say that he had the potential to be a big-league pitcher. In 1948, Phil went to work for North & Judd, a precision manufacturing company founded in 1812 and headquartered in New Britain, Connecticut. In 1970, he was named CEO of the company. Brown retired to Boothbay, though he rarely returned to Vinalhaven. He died in 2003.

Frank Peterson (VHS '38), played first base on the high school team with Phil Brown. Following graduation, he went to the University of Maine at Orono, where he got his civilian pilot's license while an undergraduate. When war broke out, he joined the Air Transport Command and flew air force equipment and personnel from Africa to India. After the war, Frank became a commercial airlines pilot, flying planes for New England Air and

Dr. Ralph Earle enlisted in the Medical Corps in 1942. After World War II, he returned to Vinalhaven and served as the island doctor for thirty years. *Courtesy of the Vinalhaven Historical Society.*

Delta Airlines for thirty-eight years until he retired in 1980. Frank currently spends his summers on Vinalhaven and winters in Florida.

In November 1945, First Lieutenant Ralph Earle, MD, returned from three years of serving in the air force. Like many young men just back from the war, he was trying to decide how to spend the rest of his life—in his case, where to resume his medical career. Earle had grown up in Philadelphia, graduating from Hahnemann Medical School, where he had completed the four-year program in two years. From 1937 to 1942, Earle had what he considered to be a "dream job" for a young man just out of medical school—he served as the Vinalhaven island doctor. In 1942, he enlisted in the Air Force Medical Corps, realizing the military's desperate need for doctors.

In November 1945, Dr. Earle was invited to meet with the Vinalhaven Selectmen, members of the Lions Club and two summer residents who, as former naval officers, had access to surplus naval diagnostic and therapeutic equipment. The result was the formation of the Islands Community Medical Services, Inc., established in 1946 as a tax-supported, nonprofit organization to "operate a dispensary on Vinalhaven." Dr. Earle was also interested in helping the young people of Vinalhaven, and through his efforts a community hall and credit union were established. Earle continued to serve as the island doctor for Vinalhaven until his death in 1975.

Postwar Change

The demographics of the island had begun to change during the late 1930s, as people left for better-paying defense jobs on the mainland. Some folks returned after the war, others did not. The island drew veterans like Arnold Barton and John Beckman back to resume their lives on the sea, while others like Phil Brown and Frank Peterson sought their fortunes elsewhere. Of the twenty-seven men and women who went to work for Pratt-Whitney in Hartford, Connecticut, almost half did not return, although several have come back since as retirees. Others took advantage of the GI Bill and went to college, courtesy of the United States government.

"Vinalhaven Resounds With the Noise of Busy Builders" read a headline in the March 1948 issue from the now defunct *Maine Coast Fisherman*. The article by Larry Gould reported that "Vinalhaven is proud of its boat builders; both of their quality and number. A 'cruise' around town includes eight or nine 'ports of call' where saws rasp, hammers pound and planes shave curls of clean-smelling wood in island boat shops." With the price of lobsters still low, a number of ex-servicemen had begun to make boat

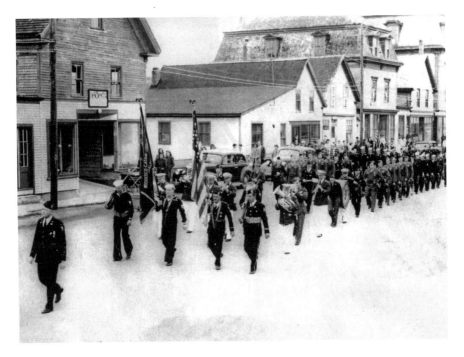

Memorial Day parade on Main Street in the late 1940s. *Courtesy of the Vinalhaven Historical Society.*

building their part-time, if not full-time, business. A good example was Bob Johnson, who spent two and a half years in the Pacific as a member of the Engineer Corps. When he returned, Bob opened a boat shop in partnership with his brother-in-law, Edwin Maddox. Bob's first boat was the *Hazel R.*, which had the unusual distinction of appearing in the 1948 Twentieth Century Fox movie *Deep Waters*, filmed on the island and starring Dana Andrews and Cesar Romero.

Bob Johnson was just one of a generation of Vinalhaven boat builders who helped to pump life into Vinalhaven's economy when they returned to the island in the years immediately following the war. The legendary Gus Skoog, Buddy's father, was another. Gus built close to 80 boats before his death at ninety-one in 1987. Phil Dyer, whose father Les bought the *Hazel R.* from Bob Johnson, finished his 100th boat recently and shows no signs of slowing down at the age of eighty. For Phil, as for so many islanders of his generation, World War II was a watershed event in his life.

JACK ELLIOT: THE VIETNAM WAR HERO FROM THOMASTON

Arthur "Jack" Elliot was killed over forty years ago on December 29, 1968, at the age of thirty-five. A fifth-generation native of Thomaston, Lieutenant Commander Elliot was leading a PBR (Patrol Boat River) squadron when he was hit by a B-40 rocket, which killed him instantly. Water jet–driven PBRs had a shallow draft, which enabled them to traverse rivers, streams and even swamps as they attempted to stem the flow of arms and ammunition coming from China and Cambodia into North and South Vietnam.

PBRs should not be confused with PCFs (Patrol Craft, Fast) the so-called Swift Boat that Senator John Kerry unwittingly helped to popularize. The PCFs were also heavily armed, but they were longer, had a deeper draft and were primarily designed for coastal, as opposed to river, patrols.

Lieutenant Commander Arthur J. Elliot was killed in 1968 while commanding a PBR (Patrol Boat River) squadron in Vietnam. *Courtesy U.S. Navy official photo.*

Jack Elliot grew up in a seafaring family. Both his father and grandfather were owners of the Dunn & Elliot boatyard in Thomaston. Jack's paternal grandfather, Arthur James Elliot, was a schooner captain who had earned his captain's license at nineteen. In 1920, he launched *Edna Hoyt*, the last five-masted schooner ever built. Dunn & Elliot began as a sail-making business in the mid-nineteenth century. Starting in 1880, however, the firm expanded into shipbuilding and launched thirty vessels, including *Hattie Dunn*, which was sunk off the coast of Massachusetts by a German submarine in 1917.

Dunn & Elliot was just one of several shipyards in the Thomaston area when Elliot was born in 1933. Growing up in Thomaston, Jack came to love the sea. He worked in the family yard and was taught to sail and fish by his father and by "Captain Arthur," his grandfather. As a teenager, Elliot was a counselor at the nearby boys' camp, Medomak, where he taught sailing.

The oldest of three boys, Jack graduated from Thomaston High School in 1950 and Gorham State Teachers College in 1955. The following year, he made repeated applications to Officers Candidate School (OCS) in Newport, Rhode Island, but was rejected each time due to bad eyesight. When the navy finally lifted its restriction on glasses, Elliot was accepted in June 1956. Four months later, he was commissioned an ensign in the Naval Reserves.

For the remaining twelve years of his life, Elliot sailed all over the world, starting in 1959 as a deck officer on the Bath-built destroyer *Lyman K. Swenson*. His career continued with a tour of duty on the light cruiser *Little Rock*, where he met Jerry Dupuis, a font of information about Elliot the man and his ambitions. According to Jerry, "Jack had a dream to command a PBR. To do this he needed to be flag lieutenant to an admiral, a post he achieved in 1963." In the process, Elliot served on ships in the Atlantic and Pacific Oceans, as well as in the Mediterranean Sea. Then, in 1968, he volunteered for duty in Vietnam.

When Elliot was named commanding officer of PBR Squadron 57 in the Mekong Delta area, the United States was not at war with Cambodia. The conflict, however, had escalated to the point where U.S. admiral Elmo Zumwalt saw the need to interdict the flow of arms and troops from Cambodia into South Vietnam. Three thousand miles of rivers, canals and small streams laced the Mekong Delta, and Zumwalt realized that whoever controlled the waterways controlled the heart of South Vietnam. Thus the "Brown Water Navy" was born. For almost a year, Jack Elliot participated in this river war and contributed significantly to the planning and execution of major campaigns, including "Giant Slingshot" and "Parrot's Beak."

Commander Elliot was killed while he was returning with his squadron of twenty PBRs from a mission on the Vam Co Dong River, one of the many streams in the Mekong Delta. The trip upriver, which was densely forested on both sides, was uneventful, but they had been spotted by the Viet Cong, and on their return the patrol ran into an ambush. When the squadron entered one of the many small lakes through which the river flowed, it came under fierce attack. It was the perfect place for an ambush, since the thick jungle foliage made it difficult to spot the enemy and the downstream exit point was not visible from the middle of the lake.

As Viet Cong shells rained down on his command, Elliot desperately circled the lake in his patrol boat, seeking the exit point. When he found the opening, he stationed his vessel in a position to direct the rest of the flotilla out of the area. His boat was about to leave when he was mortally wounded by a rocket. Fortunately, his crew and the other boats made it back to their base safely. Ironically, Elliot's tour of duty had officially ended, but his replacement had requested a postponement. Sadly, Lieutenant Peterson, his relief, was also killed in the action.

Elliot was posthumously awarded the Bronze Star with Combat "V." It should be noted that most Bronze Stars do not have a "V" attached, denoting valor. The "V" is awarded in particular instances of combat heroism. The citation read:

> *To Lieutenant Commander Arthur James Elliot II for heroic achievement and display of professional skill and courage, he immediately directed accurate and effective return fire while his boat was breaking contact and clearing the danger area…His inspiring leadership, courage and devotion to duty were in keeping with the highest tradition of the United States Naval Service.*

On October 15, 1973, the keel of a Spruance-class destroyer was laid by the Ingalls yard in Pascagoula, Mississippi. Less than two years later, Jack's mother, Helen, christened the ship USS *Elliot* in honor of her son. It was the first ship in the navy to be named after a hero from the Vietnam War. Elliot's brother, John, told me recently that "half the town of Thomaston went to Mississippi for the ceremony."

Following extensive shakedown training, USS *Elliot* was commissioned on January 22, 1977. Before joining the Pacific fleet, however, it stopped in Rockland on August 25–28, 1977. During the four-day stay, the ship hosted several thousand visitors and took 650 guests on a six-hour cruise. USS *Elliot* remained in active service as a member of the U.S. Pacific fleet until decommissioned on December 2, 2003.

The destroyer USS *Elliot* was commissioned in 1977. It was the first ship in the navy to be named after a hero of the Vietnam War. *Courtesy of the Department of Defense.*

USS *Elliot*'s coat of arms is a crest composed of a mainmast and mainsail with a pine tree emblazoned on the sail. This symbolizes the Elliot family's long association with the nautical heritage of the state of Maine. The ship's motto—"Courage, Honor, Integrity"—is representative of the values that characterized Lieutenant Commander Elliot throughout his distinguished career.

PART IV

PRESERVING THE PAST

THREE ISLAND HISTORICAL SOCIETIES: NORTH HAVEN, ISLESBORO, VINALHAVEN

North Haven

On a rainy night in November 1975, sixteen people gathered at the home of First Selectman Dick Bloom on North Haven Island to discuss the possibility of forming a historical society. The enthusiasm of the group grew when members were shown old documents, letters, deeds and pictures that had recently been discovered. What was disturbing, however, was that many of the important papers had been found at the town dump, something that happened when old houses were sold and their attics cleaned out. The oldest document rescued from the trash was the deed of Mark Eames, dated 1817, in which he sold a lot to the town for the purpose of establishing a school.

What were such records doing in private houses in the first place? The simple answer is that there was no official storage place. Citizens who held town offices did their record keeping at home and kept papers in whatever space was available: a desk, bureau, a trunk or an attic. If office-holders were not reelected or died, important town documents were often lost.

The result of the meeting was the formation of the North Haven Historical Society in June 1976, with the stated purpose of preserving the documents, photographs and artifacts from the early days of settlement on the island. Members and other interested islanders were urged to contribute old letters and photographs; indeed "anything that happened in your lifetime and that of your ancestors that is of interest and should be recorded, no matter how trivial."

The first meetings of the historical society were held in a variety of places, including the Legion Hall, the Community School and the Town Office. Lewis Haskell was elected president, Eliot Beveridge vice-president and Edith

Lewis Haskell, the "island collector" and the first president of the North Haven Historical Society. Over the years, the Haskell house became an informal town museum. *Photo by author.*

Ames secretary. The historical society's initial challenge was to find a location in which to store the material that was beginning to accumulate. The problem was temporarily solved in 1977, when the town voted to lease a room in the former village schoolhouse, currently the Town Office Building.

Lewis Haskell is the self-styled "island collector." On trips to the dump, he told me that he would often find old iceboxes, washers and fishing equipment, all of which he salvaged. Lew tells the story that when the Pulpit Harbor store was being demolished and deliberately set on fire, he broke in and took out what he could before the smoke and flames drove him out. Over the years, Lew's house became an informal museum for island memorabilia. Indeed, it is still often referred to as "Lew's Museum."

In the 1980s, Haskell added outbuildings to his house and constructed a shed to house his growing collection of island artifacts, which included donations of old sleighs and carriages. This has since become the core of what is officially now called the North Island Museum. In 1986, Haskell gave his house, land and outbuildings to the historical society, in exchange for a lifetime lease for himself and his wife, Ida.

Sam and Eleanor Beveridge, who spent years researching specific family histories and cemeteries on the island, made other important contributions. Their maps and charts have been of invaluable help to the historical society. Seward Beacom was particularly interested in island churches and schools and has written three books on their history. All of the rights and proceeds from the books have gone to the historical society. And George Lewis has given generous financial support to several historical society projects, not the least of which was the construction of the Boat Shed. This houses a collection of small craft, including a "peapod" and one of the last of the wooden North Haven Dinghies, built by Bud Thayer and donated by the Lamont family.

The historical society sponsors fundraisers, which in the past have included shows by artists like Frank Benson and Beatrice Van Ness. As Dick Bloom said, "We keep our finger on the pulse of the local art community. Once we even borrowed pictures from the Farnsworth Museum in Rockland for a weekend." The society also sponsors an annual "Special Exhibition." In 2008, it was From Candles to Cables: A History of Lights on the Island. Previous exhibits have featured hand-carved decoys, homemade christening gowns and various types of period hats.

The recently completed North Haven Archives Center seen in the winter of 2007–8. The Archives Center houses textiles and documents in a fire-retardant, climate-controlled environment. *Courtesy of the North Haven Historical Society.*

Next to the North Island Museum and its outbuildings is the historical society's impressive and recently completed Archives Center, which houses textiles and documents, as well as an excellent reference library. Everything is contained in a fire-retardant, climate-controlled environment. Fundraising for this project went on for nearly a decade, and an endowment was established through the generosity of both the year-round and summer residents.

In 2008, the Island Institute in Rockland provided financial support for the historical society by appointing Betsy Walker an Island Fellow. Betsy's work is primarily situated at the Archives Center cataloguing and conserving the collections, though she also works as the society's liaison to the North Haven Community School located next door. This is the first time that the historical society has had a paid employee, current historical society president Nan Lee told me.

As the historical society has become an important resource for the island, so has the Town of North Haven recognized its efforts, by providing an annual grant of $5,000.

Islesboro

Mary Rolerson Grinnell and her brother, Jesse Rolerson, founded the Islesboro Historical Society in 1964. In addition to collecting, preserving and displaying artifacts from the island, the bylaws stated that a primary purpose of the society was also to update John P. Farrow's *History of Islesboro*, originally published in 1893.

The Islesboro Historical Society & Museum, as it is called, is housed in an old, three-story building formerly called the meeting-house that was built in 1894. In 1906, it became the high school for the island and remained so until 1942. At that point, the grade schools on the island were consolidated and joined the high school in the building until the early 1950s.

Following extensive renovation, the former school building became the Islesboro Historical Society & Museum. Before that, I was told, "There was just some old stuff in the town hall." By the time the historical society opened its doors, the island school had moved to its present location, the former Dark Harbor summer cottage of John Atterbury.

In the summer of 2008, island historian and longtime resident Paul Pendleton gave me a tour of the building. Paul went to school in the old Meeting House and graduated in 1943. On the first floor there is a large multipurpose room with a stage called Paul Pendleton Hall. When I commented on this, Paul modestly said, "It was a complete surprise. John

The Islesboro Historical Society and Museum. Built in 1894, it was originally the island meeting-house. In 1906, it was the island school before it became the historical society in the 1960s. *Photo by author.*

Mitchell, who was president of the historical society at the time, kept talking about this guy who has done this and that, and suddenly I realized he was talking about me and they were going to name the hall after me." Pendleton Hall is a true multipurpose room and is used for numerous events and displays throughout the summer.

On the next floor, evidence of the former school was clearly apparent. The main room on the second floor of the museum is set up to resemble a 1930s classroom. Life-sized silhouettes depicting children sitting at their desks are arranged in orderly rows around the room. Information about the history of Islesboro is presented on the back of each of the cutouts. The second floor has another interesting room, which recreates the F.S. Pendleton & Company Store, which for one hundred years was the largest general store on the island. On the wall of the room there is a large photo of the store in its early days. Pieces of original furniture have been donated, and items that were sold one hundred years ago are displayed around the room. The Pendleton Store closed permanently in 1979.

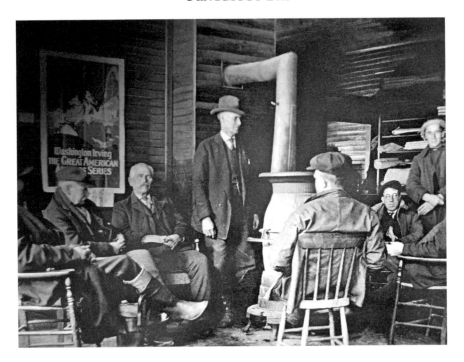

F.S. Pendleton & Company Store, Islesboro, circa 1910. For one hundred years, it was the largest store on the island. *Courtesy of the Islesboro Historical Society.*

The former school science room, also on the second floor, is now called the Changing Exhibit Gallery and features a new exhibition each year that features something special from the museum collection or works by someone from the island. In 2007, for example, it was "knitting and netting." In 2008 and 2009, the art of longtime summer resident Charles Dana Gibson was featured. Gibson (1867–1944) was an American graphic artist and painter, noted for his creation of the "Gibson Girl," a representation of the newly independent American woman at the turn of the twentieth century. Gibson became editor and then owner of *Life* magazine and owned a large estate on nearby Seven Hundred Acre Island.

On the third floor, archivist Bunny Logan identifies, catalogues and processes the many artifacts that the museum and historical society are constantly acquiring. The room also contains a large number of objects that are not currently on display or are in the process of being restored. The archives room is available to all interested visitors for historical research, genealogy work and cemetery plot locations.

Vinalhaven

As on Islesboro, the Vinalhaven Historical Society is housed in an old building. The structure was originally a Rockland church that was built in 1838. In 1875, the Vinalhaven Young Men's Association bought it at auction for $1,300. The building was taken down in sections and transported across Penobscot Bay to its present location on High Street, where the original idea was to have it serve as a church. In 1878, however, it was bought by the town and used for town meetings until the 1920s, when the meeting location was changed to Memorial Hall. Over the years, the old building was leased out for a variety of functions. It has been a dance hall, a roller-skating rink, a theatre for traveling troupes and a headquarters for Smith's Vinalhaven Band. More recently, the building was used as a school gymnasium (the lines are still visible on the floor) and a youth center.

The Vinalhaven Historical Society was organized in 1963 with the purpose of collecting, identifying, preserving and exhibiting information and artifacts that illuminate the history of Vinalhaven and its families. Much of the early impetus for the organization came from Ray Sennett, principal of the high school, and Elliot Hall, a retired telephone systems engineer, who had returned to live on the island.

We have minutes of the first meeting of the historical society that was held in the vestry of the Union Church on August 23, 1963. Ray Sennett read a series of objectives to an interested group of approximately thirty people. At subsequent meetings, the bylaws were accepted, a schedule of dues for members proposed and Elliot Hall was elected president. One of the bylaws proposed that the name of the society be in two words, "Vinal Haven," which is the way the island was originally identified. If this proposal was accepted, it did not last for long.

By 1966, artifacts and other donations had accumulated to the point where storage was a problem. At that point, Director Bob Tolman proposed to a town meeting that the historical society move into the old town hall. Three months later, the proposal was accepted, with the understanding that the town would pay the taxes and that the historical society would maintain the building with proceeds from membership dues and donations.

In 2003, the Vinalhaven Historical Society celebrated its fortieth anniversary. The guest book tells us that two thousand people from twenty-one countries (including Tonga and Niger), forty-four states and ninety-six Maine towns stopped by for a visit that year. Groups came from Elderhostel, the Penobscot Language School in Rockland and Olivet College in Michigan. During the winter, many island residents volunteered their services to help

In 1964, Elliot Hall was the first president of the Vinalhaven Historical Society. *Courtesy of the Vinalhaven Historical Society.*

with specific requests. Genealogy continued to be a major focus, with inquiries about family history coming from literally all over the country.

In 2005, the Vinalhaven Historical Society paid tribute in its annual newsletter to longtime volunteer co-directors Roy Heisler and Esther Bissell, who stepped down after years of dedicated and distinguished service. The tribute went on to say that it was "impossible to record all their accomplishments though we well know of their 'almost every-day service, answering inquiries and extending greetings to thousands of visitors and making the Museum a warm and friendly place.'"

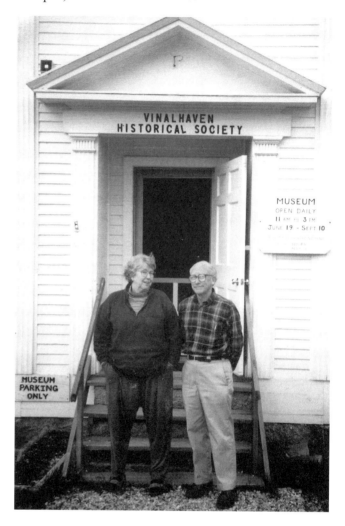

Esther Bissell and Roy Heisler were the longtime co-directors who guided the Vinalhaven Historical Society into the twenty-first century. *Courtesy of the Vinalhaven Historical Society.*

Roy and Esther are known for many lasting achievements: retrieving over five hundred glass plate negatives of local portraits and Vinalhaven scenes from the early 1900s by the Vinalhaven photographer William H. Merrithew; writing and assembling photos for the book *Vinalhaven Island: A Pictorial History*, which has gone through three reprints; organizing an exhibit at the Cathedral of St. John the Divine in New York about the eight giant columns that were quarried, carved and polished on Vinalhaven; originating an annual newsletter, which focuses on the achievements, needs and goals of the society; and establishing annual exhibits for the museum—recent topics have included "Where the Granite Went," "Island," "Architecture," "The Civil War," "Ship Building" and "The Bodwell Granite Co. Store."

Current president Bill Chilles says, "We are always looking for more room, since we have accumulated more artifacts than can ever be displayed at one time." Four years ago, the historical society was fortunate to lease the nearby Advent Chapel, formerly the Boy Scout hall, as a storage facility for archives and artifacts. A fire-retardant, climate-controlled vault was installed as a place to safeguard original documents, glass plate negatives and ledger books, as well as the numerous Bodwell Granite Company records.

The Vinalhaven Historical Society is ably led by President Bill Chilles and Executive Director Susan Radley, as well as a number of faithful volunteers. During the winter, they work on a variety of projects, including the genealogy of island families and the duplication of original files and photos.

On July 24, 2008, the Swans Island Library (also known as the Old Atlantic Schoolhouse) was destroyed by fire, most likely from a lightning strike. The fire was a sobering reminder of how vulnerable old buildings are and how important it is to duplicate and protect the collections that they house. The almost total loss of the library and its contents was devastating for Swans Island. Tragically, historic documents from Seaside Hall had recently been moved to the library. The result was the loss of artifacts, archival material and hundreds of historic photographs and records.

As already noted, in the last decade North Haven and Vinalhaven have gone to considerable expense to safeguard their collections, Vinalhaven by installing a fire-retardant, climate-controlled vault and North Haven with the construction of a separate building, the Archival Center.

Island (and for that matter, mainland) historical societies come in different sizes and shapes. Staffed almost entirely by volunteers, their missions as centers for the preservation of local history are similar. In the summer months, each institution becomes an active education center for its town, presenting lectures, films of local interest and "walks," as well as a variety of special exhibitions. North Haven is fortunate that its community school is adjacent to the town historical society, although the Islesboro and Vinalhaven Historical Societies also open their doors to students, young and old, wishing to learn more about their island's history. The past forty years have seen each institution emerge as a vital member of its Penobscot Bay community.

PENOBSCOT BAY AND BEYOND

HEAVY FREIGHT: WHEN VINALHAVEN GRANITE TRAVELED THE COUNTRY

The names remind one of an Amtrak schedule: Boston, New York, Philadelphia, Washington. When you add Chicago, St. Louis, Detroit, Cleveland, Pittsburgh and Cincinnati, you have all the cities in the original American and National Baseball Leagues. And these are just a few examples of "where the granite went" from Vinalhaven. One hundred years ago, granite from the island quarries was shipped to twenty-three states, mostly in the eastern half of the United States. Records in the Vinalhaven Historical Society indicate that stones went for banks, bridges, breakwaters, courthouses, customshouses, libraries, lighthouses, post offices and paving blocks. In addition, it went for assorted monuments, forts, train stations and even a jail. In Maine alone, granite went to dozens of different building sites, including a load of twenty-four thousand tons for the Rockland Breakwater, twelve miles across Penobscot Bay.

In the early nineteenth century, Vinalhaven was a quiet fishing and farming village of perhaps one thousand souls. The first granite quarrying is reported to have occurred in 1826, when a man by the name of Tuck quarried a boatload of stone from Arey's Harbor to be used in the construction of a state prison in Charlestown, Massachusetts, which is now part of Boston. It is said that Mr. Tuck, a quarryman from New Hampshire, brought his own workmen with him, as well as "tools, provisions and a goodly supply of rum." The stone was shipped to Boston in the schooner *Plymouth Rock*.

The end of the Civil War ushered in an era of massive federal, state and private building projects. The United States had expanded to the Pacific, and national pride was demanding that the country build impressive buildings similar to those that wealthy Americans had seen in Europe. Granite from

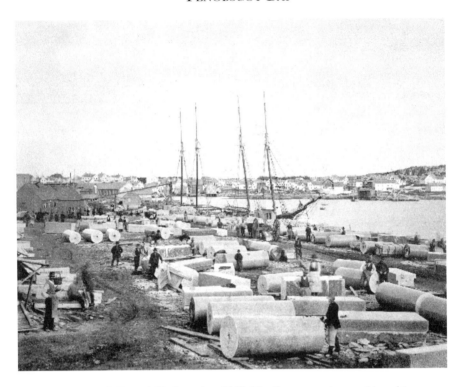

The shipping wharf, Carver's Harbor, circa 1900. Vinalhaven granite was shipped to twenty-three states, mostly in the eastern half of the United States. *Courtesy of the Vinalhaven Historical Society.*

Maine was readily available because of the relative ease of shipping by water to ports along the East Coast. Vinalhaven's granite was prized for its quality. The gray and blue-gray stones were the principal varieties and were found in both fine and course grain. "Vinalhaven Black," although rare, was particularly prized. A reporter wrote that Vinalhaven had "material enough in the beautiful granite which abounds to employ men for a century to come."

The Bodwell Company

The two men most responsible for the development of Vinalhaven's granite industry were Moses Webster and Joseph Bodwell, the latter destined to be governor of Maine. Both Webster and Bodwell came from humble circumstances, and theirs was a rags-to-riches story. Webster came to Vinalhaven from New Hampshire, and Bodwell arrived from Massachusetts in the early 1850s. At the start of their joint operations, they had but a

single team of oxen, which Bodwell drove, shod and cared for while Webster worked in the quarry and tended the books. In 1853, the firm of Bodwell and Webster was formed. Contracts were secured to supply stones for breakwaters, lighthouses and federal forts on the East Coast.

In 1871, the firm of Bodwell and Webster was incorporated as the Bodwell Granite Company, with Bodwell president and Webster vice-president. Shortly afterward, the company got a contract to provide granite for the State, War and Navy Department Building, now known as the Executive

Much of the granite for the Brooklyn Bridge's distinctive towers came from Vinalhaven. When the bridge opened in 1883, it was the longest suspension bridge in the world. *Courtesy of the Vinalhaven Historical Society.*

Office Building, in Washington. This would be the most important structure built by the firm for the United States government. The list of contracts filled by the Bodwell Company is endless. In the nineteenth century, some of its more notable projects included the Chicago Board of Trade, the Pennsylvania Railroad Station in Philadelphia, the Brooklyn Bridge, the Union Mutual Life Insurance Building in Boston and a small amount of stones for the Washington Monument, delivered in 1884.

The effects on Vinalhaven were significant, as the island underwent "the greatest financial boom in its history," according to local historian Sidney Winslow. Wages were good and prospects for the future looked even better. Granite cutters poured in from the British Isles, especially from Scotland; the population on the island rose to almost three thousand people by 1880. By 1872, the Bodwell Company had become the dominant economic force on the island, with over six hundred men on the payroll. It should be pointed out that Bodwell was simply the largest of a number of granite businesses on the island. Other firms employing between twenty-five and fifty men included Booth Brothers, J.P. Armbrust, J.S. Black & Co. and the Roberts Harbor Company. Of course, there was also a flourishing granite operation on nearby Hurricane Island.

But there were clouds on the horizon. While the granite industry was prospering in the 1870s, men were earning $1.50 for a brutal ten-hour day. In 1876, three hundred men were laid off. This action encouraged Vinalhaven's granite workers to form a union. There were strikes by workers and lockouts by the owners, who proceeded to bring in scabs to keep the quarries open. Wages improved but only slowly. It wasn't until 1905 that skilled workers on the island were earning $3.40 for an eight-hour day. When Bodwell died in 1887, shortly after becoming governor of Maine, the eulogies rolled in: "His repute in the business world stood untarnished. He was a man of untiring industry and uncommon natural capacity. Vinalhaven will long revere his memory." Maine historian Roger Grindle asked, "One wonders to what degree the average working man held this view."

In spite of periodic labor strife, however, both government and private contracts continued to pour in. The Bodwell Company specialized in big jobs. From the 1880s to 1910, Bodwell quarries supplied stones for the elaborate U.S. Customs House façade in New York, as well as for post offices in Washington, St. Louis, Pittsburgh, Cincinnati and Kansas City. And this is only a partial list. Of particular note were the five beautiful eagles created by Scottish master carvers that adorned the façade of the Buffalo Post Office. When asked how he did it, one of the carvers replied, "Oh, there's really nothing to it. The eagle was already in the stone and all I had to do was chisel it out."

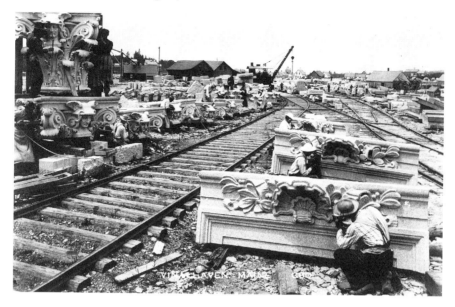

Granite carvers at work. Sands Quarry, Vinalhaven. *Courtesy of the Vinalhaven Historical Society.*

There were two other transactions of interest. In 1872, Brooklyn, not yet a part of New York City, sold a steam fire engine to E.P. Walker (an official of the Bodwell Comany) in partial payment for granite furnished for the Brooklyn Bridge. And in 1877, the City of Troy, New York, ordered a monument in honor of General John Wool, a veteran of the Mexican and Civil Wars. The seventy-five-foot, 650-ton stone was shaped and polished in the Bodwell Granite Company finishing shed. It was said to be the largest piece of granite ever quarried in the United States up to that time.

St. John the Divine

In 1899, the Bodwell Company secured its most famous contract, which was to provide eight enormous columns for the Cathedral of St. John the Divine in New York City. The project presented a number of problems, the least of which was getting the stones out of the ground. Initially, columns were not even part of the original conception for the cathedral. However, in spite of the added expense, $25,000 for each column, the decision was made to proceed when architects persuaded the church trustees of how imposing the pillars would be. An exceptional vein of stone was found in the Wharff Quarry on the western side of the island, and work was begun in April 1899. Once quarried, the stones were polished on a special lathe especially

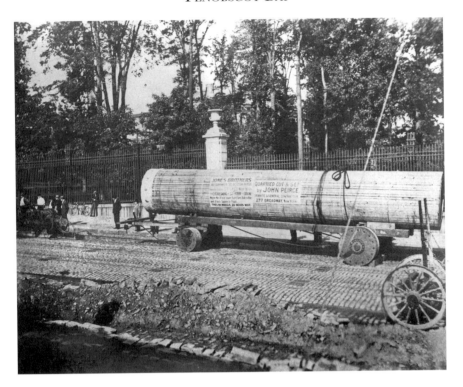

One of the eight columns for the Cathedral of St. John the Divine in New York City being transported along Amsterdam Avenue to the building site on 112th Street. *Courtesy of the Vinalhaven Historical Society.*

designed by Bodwell engineer E.R. Cheney. When the first three columns broke on the lathe, the decision was made to make the columns in two pieces. The combined height of fifty-five feet would make them twice the height of the columns of the Parthenon and rival those of St. Isaac's Cathedral in St. Petersburg, Russia.

The columns were loaded, two at a time, aboard a specially designed barge, the *Benjamin Franklin*, and towed to New York by the schooner *Clarita*. They arrived in July 1903 at West 134th Street on the Hudson River. Transporting the two stones (weighing 130 tons) from the dock to 112th Street and Morningside Heights was a formidable task. Due to the weight of the stones, a special truck with huge wooden wheels had to be designed and paving blocks had to be removed from the street. It took nineteen days for the first columns to be laboriously moved down Amsterdam Avenue before they arrived at the cathedral grounds. A 10-ton tractor provided the power for a winch, which moved the truck three hundred feet at a time. By the time the next two columns arrived, the engineers had sped up the moving process

and subsequent trips took less time. The project was completed in January 1904, when the final columns were shipped to New York. By the end of 1904, all eight columns were in place and ready for the cathedral to be built around them. Work proceeded slowly. The first services were finally held in the nave of cathedral on December 6, 1941. The next day, Pearl Harbor was attacked and the United States entered World War II, further delaying construction. Work continues on St. John the Divine at this writing.

The Technology

For centuries, the quarrying of stone was done by hand with a hammer and chisel. Even though granite is a very hard rock, most stones will split cleanly when the proper breaking technique is used. Wedges and shims (also known as plugs and feathers) have been used for years and are still very effective for small jobs and for specialized carving. Hand drilling, however, was tedious and bits needed to be sharpened frequently. Beginning in the latter part of the nineteenth century, drilling equipment began to improve with the development of steam-driven drills. Then in the early twentieth century, pneumatic drills, using compressed air, were developed, which enabled quarrymen to work much faster. Compressed air used in conjunction with the pneumatic drill was not only more economical, but it also reduced painful recoil for the driller. To quote a former quarryman, "After they got pneumatic tools all you had to do was press the handle down and you could drill a hole in 30 seconds. It made quite a difference." Not surprisingly, compressed air hammer drills were soon in use in quarries everywhere. At the same time, mechanical drill sharpeners were developed to recondition bits. To quote from a United States Geological Survey prepared by Nelson Dale in 1907, "A modern quarry blacksmith shop is a marvel of speed and accuracy." Vinalhaven's newspaper proclaimed, "Last Friday 1743 drills were sharpened for workmen in Sands Quarry with Fred Byard, Walter Hopkins and William Hopkins doing the sharpening."

Most quarries on Vinalhaven and elsewhere on the Maine coast were located near the shore, so that as the stones were cut they could be rolled or dragged to a nearby pier. Until the use of railroad cars, teams of oxen and horses hauled stones, often in a special wagon equipped with a derrick or crane called a "galamander." A rope tackle was attached to the derrick, which lifted large pieces of stone and suspended them between the twelve-feet-in-diameter rear wheels. It is reported that well into the twentieth century there were as many as six galamanders working in the Sands Quarry on Vinalhaven during an average day. Four teams of horses drew the largest galamander,

named Jumbo. Today, a restored galamander sits on Vinalhaven's village green, a symbol of an era when granite was king.

A word about dynamite, used to break up waste rock (grout) or to create large fractures. Explosives were also used for smaller jobs, although it took an expert not to create the tiny fractures that often wouldn't appear until a piece had been shaped and polished. By 1915, an article in *Engineering News* stated that blasting had been "done away with except in the case of the hardest and toughest stone." Although fatalities were rare, blasting could cause some terrible accidents. Alexander Beaton, foreman of paving operations at Dushane Hill, was blown up and "mangled in a fearful manner" in 1883. What made the tragedy even more poignant was that a few years previously his brother James had been crushed by the wheels of a steam engine at Sands Quarry. Then on November 24, 1899, Mr. Charles Ingerson, forty-five-year-old foreman of the Wharff Quarry, was killed when the time-delayed fuse that he lit exploded prematurely. Mr. Ingerson, reported to be "an industrious, upright and honorable man who will be greatly missed," left behind a wife and three children

There were also plenty of close calls. The house of Captain Samuel Burgess, "situated near Pequot came near being a wreck last week when a large rock weighing nearly a ton flew the length of the house barely touching the shingles. Mr. Burgess, frightened at its narrow escape, has had the building moved to safer quarters." And there is the story of Old Deborah, one of the oldest horses at Booth's Quarry, who fell into the water near the Sands wharf. Charles Moody made a "bold leap" into the water and held her head up until a boat was brought to help her get out of the water. Old Deborah was reported as "having only a few cuts on her legs" from her unexpected swim.

Vinalhaven historian Sidney Winslow provides some perspective when he reminds us in his book, *Fish Scales and Stone Chips*, that as a child in the early twentieth century he "paid little attention to the heavy blasts that were set off just a short distance from our dooryard (near Sands Quarry) even though the air was often filled with sticks and stones because of them." One cannot help but compare Winslow's attitude with the concerns expressed by island residents at the disruptions to daily life caused by dynamite blasting for the new sewer system on Vinalhaven a few years ago.

A quarryman's life was not all tedium. On Labor Day 1891, a well-publicized baseball game between the paving cutters and quarrymen and the granite cutters took place. The game was played on the Bodwell Company recreational grounds on Lane's Island and was won by the granite cutters 18–3. An article in a Vinalhaven newspaper, circa 1890, reported that

the contest between Allie Lane and Hans Packard for supremacy in stone cutting has ended. Lane came off the victor by seven seconds having cut a double-header in three days, five hours, eleven minutes and six seconds. Packard made the same time in days, hours and minutes, but he was 13 seconds slower in completing the work.

Finally, a "Boxing Competition" was held between Lewis Hopkins and Hanse Elwell to see who could make a sill box the fastest. Hopkins's time of three minutes, thirteen seconds beat Lewis's by two seconds.

Environmental and Human Impact

If Joseph Bodwell and Moses Webster were to return today, they might be surprised to see Vinalhaven and the surrounding islands covered with trees. Pictures of the islands from one hundred years ago show relatively few trees. Wood was cut down to provide fuel for boilers and compressors, as well as heat for private homes. In fact, coal had to be imported to supplement the lack of wood. Today, the scars in the earth left by the Bodwell Company and other granite operations are less evident. Many quarries are filled with water, while others are covered with trees and shrubs. Perhaps the most obvious evidence of past quarrying operations are the loading piers (some in remarkably good condition) and the piles of granite rubble or grout on the shoreline marking the presence of an old quarry.

Historian Roger Grindle, writing in *Tombstones and Paving Blocks*, reports that "one of the complaints of many Maine granite towns was the destruction done to the streets by teams of horses and oxen transporting heavy blocks of stone from the cutting sheds to the loading piers." The streets could be repaired; however, the men's health was not so easily treated. The most frequent injuries suffered by workers were crushed hands and feet. Accidents also occurred from improperly used or faulty equipment. Period newspapers were filled with references to derricks and guy (guide) wires "giving way." There was also the more lethal "stonecutters consumption," or "deadly dust" as it is called today, which came from working in enclosed areas during the winter months. Leigh Williams, a retired quarry worker, remembers "a lot of dust in stone cutting. We had our faces right down on the tools and because of the compressed air there were particles flying all around." Williams also commented on how it felt to use the tools. "It caused your fingers to get all paralyzed. Every time the day would get cold our fingers would all turn white, just like a dead man's. Mine did, but I've been out of it

Quarry workers in the pit. Quarry work was dangerous and accidents were frequent. *Courtesy of the Vinalhaven Historical Society.*

for so long that they've come back." Cutting stones frequently led to silicosis, a respiratory disease caused by the inhalation of silica dust. Proposals were made to suspend cutting operations in midwinter because of "the obnoxious dust." Unfortunately, as Roger Grindle tells us, "Various types of ventilating devices were tried, but none worked satisfactorily,"

In 1919, the Bodwell Company store closed, selling all of its goods. The company had gone out of business, ending nearly fifty years as a leader of Vinalhaven's economy. What caused the granite industry to decline on the island and elsewhere? Changes in architectural styles and new and lighter construction materials (structural steel and concrete) were appearing at the beginning of the twentieth century. Builders were now using limestone, which was cheaper and easier to work with. Granite had its limitations as a building material. Because of its weight, it was impractical to use granite for buildings that were more than five or six stories high. Ironically, transporting granite by sea had become more expensive. Bad weather could delay shipping and Vinalhaven's ten- to twelve-foot tides limited when it was possible for vessels to sail.

The cutting and shipping of paving blocks continued on Vinalhaven up until 1939. Originally, granite companies had considered the quarrying of paving stones a secondary operation. Throughout the '20s and '30s, however,

a number of smaller quarrying operations led by "paving king" Joseph Leopold found markets in East Coast cities to provide stones for streets. Leopold alone is said to have shipped 4 million blocks a year, mostly to New York. In 1938, however, Joseph Leopold died and the east Boston quarry closed down the next year. Since then, there have been only occasional contracts. The Swensen Co. obtained the most noteworthy of these in 1969 to supply decorative stones for the Dupont Brandywine Building in Wilmington, Delaware, and the Michigan Telephone Building in Detroit in the early 1970s.

Former Vinalhaven resident Dr. G. Langtry Crockett provides us with a wistful epitaph for the end of the quarry era when in 1913 he wrote:

> *Out from this quarry came the stone they dressed for temples great;*
> *Those structures stand, the men are dead, for such is earthly fate.*
> *Above their graves their humble shafts commemorate their name—*
> *Those sterling workers, strong as Thor; those men of labor fame.*

PRESIDENT ROOSEVELT "GOES FISHING"

On Saturday, August 16, 1941, the presidential yacht *Potomac* emerged from the mists of Penobscot Bay and entered Rockland Harbor. President Roosevelt had been out of the country for two weeks. Why did he suddenly reappear in Rockland, Maine, of all places? Had he really been on a "fishing trip," as he told the press? If so, what was the president doing cruising off the coast of Maine, while German submarines lurked nearby?

By the summer of 1941, World War II had been raging for two years. Great Britain stood alone against the forces of fascist Germany, Italy and Japan. In June 1941, Hitler invaded the Soviet Union. Although the United States remained neutral, Washington was already providing some Lend-Lease aid to the British, even though many Americans felt that "nothing is worse than war." As British prime minister Winston Churchill stepped up his efforts to bring America into the war, President Roosevelt was faced with a dilemma. Anxious as he was to stop Hitler, he was also acutely conscious of the strong isolationist sentiment in the United States. Polls showed that 74 percent of the public wanted to stay out of the conflict.

After months of negotiations, the president finally agreed to a secret meeting with Churchill to be held in August 1941 to "talk over the problem of the defeat of Germany." This was the famous "fishing trip."

Plans had to be made carefully for both political and security reasons. Early in August, Churchill slipped quietly out of London and headed north, eventually boarding the British battleship HMS *Prince of Wales* in Scotland. As was to be his pattern for later wartime conferences, Roosevelt arranged an elaborate plan of departure. In this case, he told the world he was "going fishing" on his yacht, *Potomac*. Roosevelt kept his plans highly confidential, announcing that he was leaving Washington for a "nice quiet cruise, including some fishing." Due to the "lack of space" on the Coast Guard escort vessel *Calypso*, members of the press were not invited, a decision that irritated many members of the Fourth Estate.

Roosevelt took the train to New London, Connecticut, where he boarded *Potomac*. Once out of sight of Martha's Vineyard, he transferred to the heavy cruiser USS *Augusta*. To maintain the deception, the president's flag remained on *Potomac*. Passing through the Cape Cod Canal, *Potomac*'s captain had several crew members dress in civilian clothes and sit on the afterdeck, pretending to be the president and his party. For the next few days, *Potomac* cruised the waters off of New England. Bulletins such as the following were fed to the press: "From *USS Potomac*, All members of party showing effects of sunning. Fishing luck good…"

Meanwhile, *Augusta*, accompanied by several destroyers and the light cruiser *Tuscaloosa*, steamed to Argentia Harbor in Placenta Bay, Newfoundland. The ships carrying both leaders, however, were preceded by minesweepers and

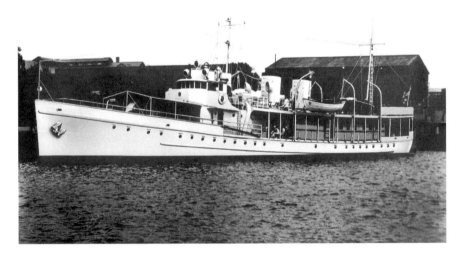

The presidential yacht *Potomac*. Roosevelt departed on his yacht *Potomac* hoping to fool the press into thinking he was going on a fishing trip. *Courtesy of the Rockland Cooperative History Project and Paul G. Merriam.*

escorted by warships. They followed zigzag courses, for fear of being spotted by German submarines. *Prince of Wales* had to make multiple course changes and at one point lost its escorts due to bad weather. Churchill, however, found the voyage restful as he read novels, watched films and played backgammon.

Upon meeting Roosevelt, his son, Elliott, who served as a temporary aide to his father, remembers saying, "You look wonderful, Pop, but how come all this? You on a fishing trip?" The president roared with laughter. "That's what the newspapers think. They think I'm fishing somewhere off the Bay of Fundy," he said. "Dad was as delighted as a kid, boasting of how he had thrown the newspapermen off the scent, Elliott recalled. "Then he told us what it was all about." "I'm meeting Churchill here," Roosevelt said. "He's due in tomorrow on the *Prince of Wales*."

The Meeting

Roosevelt arrived in Newfoundland on August 8, Churchill a day later. Although they had corresponded frequently as wartime leaders, the two men had met only once before, in 1918. "At long last, Mr. President," Churchill is reported to have said. To which Roosevelt replied, "Glad to have you aboard, Mr. Churchill." Churchill then gave the president a letter from King George IV and made an official statement, which, despite two attempts, a sound/film crew failed to record.

Each man had his own agenda. Churchill hoped that Roosevelt would agree to enter the war against Germany and Italy, whereas Roosevelt's objective was to secure a joint declaration of war aims, without committing the United States to war. For four days, the two leaders and their staffs met frequently, discussing issues and exchanging information. On Sunday morning, church services were held on *Prince of Wales*. The sun broke through the leaden skies "almost as though by signal," wrote Elliott, as the assembled company sang "Onward Christian Soldiers," reducing Churchill to tears; Roosevelt later referred to it as "a very remarkable religious service."

On August 12, the two leaders agreed on a joint declaration known to history as the Atlantic Charter. It was hoped that in addition to being a statement of Allied war aims, the document would establish a vision for a post–World War II world, even though the United States had yet to enter the war. It was not, however, a treaty, since Roosevelt knew that the U.S. Senate was not ready to approve such an agreement.

If the following principles are reminiscent of Woodrow Wilson's Fourteen Points, remember that Roosevelt had been assistant secretary of the navy

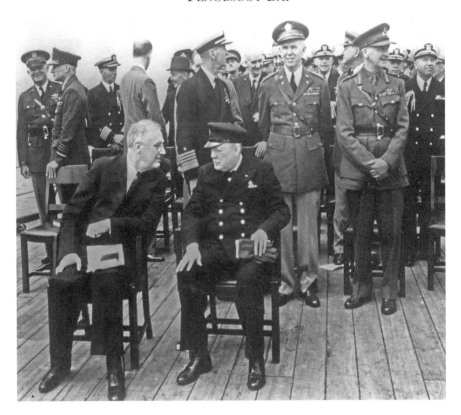

President Roosevelt and Prime Minister Churchill onboard HMS *Prince of Wales* at the conclusion of their meetings that resulted in the Atlantic Charter, August 10, 1940. *Courtesy of Roosevelt Presidential Library.*

under Wilson for six years. Just as the Fourteen Points provided a framework for ending the First World War, so did the Atlantic Charter provide the criteria for a peace settlement after World War II. A major difference was that Roosevelt had achieved a joint statement, not one issued unilaterally like the Fourteen Points. On August 14, as each leader was returning to his country, London and Washington simultaneously announced the following agreement:

1. No territorial gains to be sought by the United States or the United Kingdom.

2. Territorial adjustments to be in accordance with wishes of the peoples concerned.

3. All peoples have a right to self-determination.

4. Trade barriers to be lowered.

5. Global economic cooperation and advancement of social welfare.

6. Freedom from want and fear.

7. Freedom of the seas.

8. Defeat of aggressor nations, postwar common disarmament.

When Americans opened their morning papers on August 14, banner headlines informed them of the historic meeting and that Roosevelt was expected to come ashore at Rockland, Maine. The result was a stampede by the press to catch the next train to Rockland. The *New York Times* ran its largest headline: "Roosevelt, Churchill Draft 8 Peace Aims Pledging Declaration of Nazi Tyranny: Joint Steps Believed Charted at Parley."

En Route to Rockland

USS *Augusta* left Argentia Harbor, Newfoundland, on August 12 and proceeded to Blue Hill Bay, Maine, for a rendezvous with *Potomac* and its Coast Guard escort, *Calypso*. On August 14, Roosevelt transferred to his yacht and steamed to Eggemoggin Reach, where the party actually did some fishing. The biggest "catch," however, was eighty pounds of lobsters, which the president purchased from Deer Isle fisherman Bert Bettis. Bettis then presented the president with an extra twenty-five pounds of "super lobsters" as a special present. In a thank-you note to Bettis, Roosevelt wrote, "Your courtesy has brought added enjoyment to a most pleasant cruise I am just completing."

The next morning, August 15, was spent relaxing before the presidential party got underway about noon. What was the presidential route? A special message from Editor Robbins of the *Deer Isle Messenger* alerted the *Rockland Courier-Gazette* that after spending the night off Conary Island, the *Potomac* and its escort had passed under the recently completed Deer Isle Bridge, "probably heading for Rockland." Eventually, it was learned that after frequent stops for fishing, the president spent a quiet night in the familiar waters of Pulpit Harbor, North Haven, and that internationally known financier and prominent summer resident Thomas W. Lamont had boarded *Potomac* to pay his respects.

In fact, this was Roosevelt's third visit to North Haven. In 1933, while cruising, he had anchored his yacht, *Amberjack II*, in Cabot Cove off Pulpit Harbor to collect the White House mail pouch, which had been sent on ahead. Postmaster Herman Crockett delivered the mail and also got the president to sign the Havens Inn register. (The register also contained the signature of Civil War hero and our eighteenth president, Ulysses S. Grant,

who had visited North Haven in 1873.) FDR's second visit came in July 1936, when he met his sons in Pulpit Harbor for a cruise. "I haven't the faintest idea where I'm going, except to work to east'ard," he told newshawks before casting off. "I'm just going to loaf and have a good time," the *Times* reported of his comments.

Another Roosevelt connection with Penobscot Bay has come to light recently, when it was discovered that in 1925 he leased property and owned buildings on Vinalhaven for the purpose of impounding lobsters. The island's historical society has records showing that the land was located on the east side of Green's Island, next to Vinalhaven. (The records also show that the lease was for seven years but that it was terminated in 1928 for "non payment of rent.") Historically, the place was known as Delano Cove, which of course was Roosevelt's middle name. There is, however, no indication that he was in any way related to the Delanos of Vinalhaven.

Crossing Penobscot Bay

Potomac and *Calypso* remained anchored in Pulpit Harbor the following morning, waiting for the fog to lift, which it finally did early in the afternoon. Paul G. Merriam, Ted Sylvester and Thomas Molloy grew up in Rockland and coauthored the book *Home Front on Penobscot Bay: Rockland During the War Years, 1940–1945*. In it they wrote, "There was an air of anticipation. With advance notice thousands from the area and summer visitors planned to greet the President. Bunting hung from buildings and people made plans to take positions along the route or at the train station." As a child, Paul Merriam remembers his father saying, "Let's go see the president. I saw him, though I didn't know why he was there until much later."

The August 16 issue of the *Rockland Courier-Gazette* proclaimed, "The city was agog with excitement and rapidly filling up with summer visitors and local residents." The paper speculated that "interest is intensified that the President may launch into further details of the history-making conference between the American and British dignitaries on board *HMS Prince of Wales*." As was the case several years previously when President Roosevelt paid his first visit to Rockland, the city was filled with Secret Service men, state police and other officials. The paper went on to add that "the busiest place in the city today will be the Western Union telegraph office where preparations are being made to handle many thousand words." Sensing a deluge, manager Bert Gardner put on an extra force of fourteen operators.

Roosevelt chose Rockland as his port of debarkation for several reasons. First, it had one of the largest and most sheltered deep-water harbors on the

People, Ports and Pastimes

North Atlantic coast. In 1941, there was also a direct rail link to Washington. As already noted, Roosevelt was thoroughly familiar with coastal Maine, especially Penobscot Bay, having cruised the waters many times en route to his summer home farther Down East on Campobello Island. An avid sailor, he was called by *Time* magazine "the best yachtsman the nation ever had for President."

FDR was not the first American president to visit Rockland, nor would he be the last. Over the years, the town has had its share of presidential visitors. As previously mentioned, Ulysses S. Grant stopped in Rockland on a cruise around Penobscot Bay. Early in the twentieth century, FDR's cousin, Theodore Roosevelt, visited Rockland, and in 1910 our twenty-seventh president, William Howard Taft, made a speech and visited the lime quarry near the present city dump. In the 1950s, Dwight Eisenhower visited Rockland shortly before his nomination as a presidential candidate, and later in the decade, Richard Nixon and John F. Kennedy each visited the community on campaign swings.

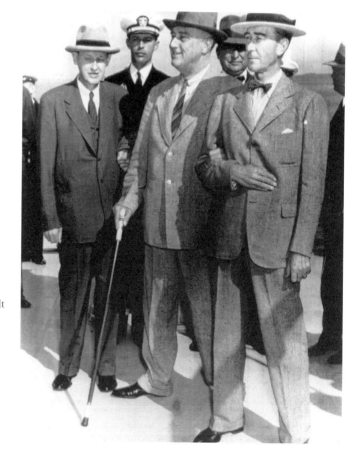

President Roosevelt and members of his entourage disembarking at Tillson's Wharf, Rockland, August 16, 1940. *Courtesy of the Rockland Cooperative History Project and Paul G. Merriam.*

The Press Conference

The nation listened as NBC newsman Ben Grauer broadcast Roosevelt's return to the United States by describing Rockland as a "quaint fishing hamlet." *Potomac* and *Calypso* passed the Rockland breakwater about 3:00 p.m. and docked at Tillson's Wharf, site of the present-day Rockland Coast Guard Station. A large contingent of reporters and cameramen, representing the major newspapers and news services, waited there, primed to question the president about his historic meeting with the British prime minister. Two dozen reporters were permitted onboard *Potomac*, where they found the president seated in the yacht's main cabin. Photographers, however, learned to their dismay that cameras would not be permitted onboard.

A smiling Roosevelt remarked that it had been foggy crossing Penobscot Bay and that if any submarines had fired torpedoes, they had not been sighted. He then made a brief statement about the trip, emphasizing the eight points upon which he and Churchill had agreed. When asked if the United States was moving closer to war, the president disingenuously replied, "I should say no." Most of those present, however, realized that America had indeed moved a step closer to war. As Paul Merriam wrote, "The reason for the President's visit to Rockland impressed upon people from the area, as well as from around the world, that the country was increasingly casting its fate with those powers fighting tyranny abroad."

Following the news conference, FDR disembarked from *Potomac* and was met by Rockland mayor Edward Veazie and other local dignitaries. He rode in an open car through town to the accompaniment of whistles and cheers from thousands of spectators. Security was tight. A Secret Service agent grabbed one bystander when he innocently reached in his pocket for a pack of cigarettes. People packed the route ten feet deep as the motorcade proceeded from Tillson's Wharf to the Main Central Railroad station on Union Avenue. Roosevelt was assisted from his car to the train, where he stood on the rear platform acknowledging the cheers of the crowd. "With shouts still ringing in the ears of the Chief Executive, the Presidential train disappeared from view," the *Courier-Gazette* article concluded.

Rockland Remembrances

John Knight was a teenager and remembers listening on a friend's portable radio to the description of FDR passing "Owls Point" and thinking the sound came from very close by:

Presidential motorcade en route to the Maine Central Railroad Station in Rockland. *Courtesy of the Rockland Cooperative History Project and Paul G. Merriam.*

We looked down to our right and there was the announcer, Ben Grauer, who was describing the atmosphere and the goings-on prior to the President coming off the Presidential yacht. After the President left for the train, a newsman with a tripod asked me if I knew of a shortcut to the railroad station. I told him I did and I carried the tripod for him. We went through the back streets and arrived at the station just in time to see the President going into his compartment on the train.

Betty Holmes Knight, John's wife to be, was standing with a bunch of her girlfriends on Union Street near the railroad station. "Everybody knew that the President was coming. Rockland was just another small town, but there he was. I remember it seemed as though we waited forever for him to appear. We spent the time singing songs led by a woman from Brooklyn. I had no idea that the President was handicapped and didn't learn until much later what he was dealing with."

One of Betty's friends in the picture was Georgia Stevens Tasho, Rockland High School class of '44. Georgia remembers being impressed

that Roosevelt was stopping in the strongly Republican town of Rockland. "Back then I was a Republican, though I supported the New Deal," she said. "Even though he was a Democrat it was really something to see a President so close. And yes, he was very handsome."

Looking back on the event fifty years later, Stephen May wrote in 1991:

> *I was ten at the time and remembered no other president. To me Roosevelt seemed a figure of gigantic proportions. Rockland was stirring with life early that morning as my father drove our Ford into town by way of Route 17. Even on short notice, buildings were awash in patriotic bunting, and crowds of hopeful Rocklanders and summer visitors alike waited for hours, hoping to catch a glimpse of the international leader... When the President's entourage appeared on deck, we knew the long-awaited moment was finally at hand. Grasping a cane in his right hand, FDR planted himself firmly on deck. Although he seemed the picture of vigorous good health we were surprised to see him make his way down the gangplank by grasping both railings, and swinging his weak legs, still encased in braces long after his bout with polio.*

Ted Sylvester recalls:

> *As kids we were pretty much isolated from the war... When President Roosevelt visited Rockland in 1941 on the eve of the war, the fact that Rockland was featured on the movie screen was big news. My recollection of the visit was a giant parade and hordes of people everywhere. I took up a position at the railroad station to try and get a glimpse of the President. As the train pulled away from the station, with the President standing on the platform, I ran up the tracks to get a better look... There's an old newsreel of a kid dressed in knickers running up the track. No one believes it, but that's me.*

George van Tassel, later a Rockland resident, was a member of the Canadian navy serving aboard a destroyer. His ship was pressed into service when a storm scattered *Prince of Wales*'s escort vessels. Van Tassel remembers, "We had no idea what we were in for. The President had sent over a package of candy, cigarettes and oranges to each seaman on his ship." (In fact, gift boxes containing cigarettes, fresh fruit and cheese were distributed to the 1,950 British seamen on four ships.) On Sunday, Van Tassel was one the fortunate sailors chosen to attend the memorable church service on *Prince of Wales*. Coming from a destroyer, he was awed by the battleship. "I will never forget

her because she was so huge." By the end of the meeting, Van Tassel said "We didn't know what had happened but we knew it was something really big."

Jim Moore was a cub reporter for the *Portland Press Herald* who was fortunate to be at FDR's press conference on *Potomac*. "The President sat relaxing in an easy chair, smoking a cigarette in his customary long stemmed cigarette holder. To set the reporters at ease, Roosevelt told the old joke about Maine people, 'the thing about Maine people is that during the summer, they fish and make babies. During the winter they don't fish.'" Jim said that he didn't ask any questions. "If I could have thought of anything world-shaking, I would have asked him, but I couldn't think of a damn thing."

Moore received the following Western Union cable from his anxious *Press Herald* editor: "Do your darnest on good descriptive yarn with snappy lead. We have faith in you here." The editor later expressed his appreciation: "You are doing grandly...You have done a swell job on what the President said. So far I can see you have everything that the Associated Press had in its interview."

As already noted, Roosevelt actually did do some fishing on the trip. When he first arrived at Argentia Bay and was waiting for Churchill, FDR and another son, Franklin, commandeered a whaleboat and did some bottom fishing for small cod and flounders. It was reported on good authority, however, that the fish were wormy and their edibility questionable. "Have one sent to the Smithsonian," the president laughingly suggested. This was followed by several unsuccessful attempts in Eggemoggin Reach shortly before the presidential party arrived in Rockland. Regarding the larger question of who caught the bigger fish, Roosevelt or Churchill, historians agree that both men were skillful anglers.

MAINE AND THE CENTENNIAL OF THE GREAT WHITE FLEET

The past few years have seen a profusion of books and articles commemorating the 100th anniversary of the circumnavigation of the globe by Theodore Roosevelt's Great White Fleet. What was it that compelled the president to send sixteen battleships on a forty-six-thousand-mile cruise around the world from 1907 to 1909 and how was Maine involved?

The short answer to the first question is that Roosevelt wanted to impress the naval powers of the world, particularly England, Germany and Japan, with the sea power of the United States. He especially wanted Japan to see that the United States Navy could shift a fleet from the Atlantic to the Pacific

and sail around the world. At the same time, he was anxious that the United States continue to play a dominant role in Western Hemisphere affairs, the so-called Big Stick policy.

To achieve these objectives, Roosevelt needed to gain popular support for the resumption of battleship construction, which had been suspended for the past two years. It is interesting that Maine senator Eugene Hale, chairman of the Naval Appropriations Committee, was an opponent of the big-ship program. This didn't bother Roosevelt, who in his typically forthright fashion, replied that he already had the money and dared Congress to "try and get it back." The irony is that even as plans were being made for the voyage, battleships of every navy were rendered obsolete with the launching in Britain of HMS *Dreadnought* in 1906, the first "All Big Gun" battleship.

There are historians who feel that the sinking of the battleship *Maine* in Havana Harbor in February 1898, and the resulting Spanish-American War ("Remember the *Maine*, to Hell with Spain"), elevated the United States to the status of a great power. Critics point out, however, that the naval victories over the Spanish at Manila Bay and Santiago de Cuba were extremely one-sided and that the United States was not yet a major naval power. That began to change in 1901 when Theodore Roosevelt became president, following the assassination of William McKinley. Roosevelt, a former assistant secretary of the navy and a friend of Alfred Thayer Mahan, who authored the classic *The Influence of Sea Power on History*, lost no time in beginning the construction of a world-class fleet of battleships.

A Maine shipyard holds the honor of building one of the first battleships in Roosevelt's fleet. *Georgia* was laid down in 1901 at the Bath Iron Works on the Kennebec River in Bath, Maine. The yard was opened in 1884 by Bowdoin alumnus and Civil War general Thomas Hyde. By 1890, with an eye to entering the growing business of iron shipbuilding, Hyde had secured the contracts from the navy for two iron gunboats, *Machias* and *Castine*. Both ships saw action in the Spanish-American War and World War I.

The stage was now set for the construction of *Georgia*, a Virginia-class battleship and typical of the pre-dreadnought battleships in the Great White Fleet. Because of its length of 441 feet and displacement of 14,950 tons, *Georgia* presented numerous challenges to the Bath shipyard. In fact, it is the only battleship ever constructed in Maine. In the sea trials to Rockland and back, *Georgia* averaged nineteen knots, making it the fastest battleship in the fleet. *Georgia* was launched in 1904. With a crew of 40 officers and 772 enlisted men, it was not only the fastest but also one of the largest ships in the new battleship fleet.

People, Ports and Pastimes

In December 1907, *Georgia*, flagship of the Second Division, joined fifteen other battleships at Hampton Roads, Virginia. In preparation for the historic voyage, each ship had been painted a vivid white with a gold bow and stern fixtures. President Roosevelt reviewed the armada and sent it on the first leg of the historic cruise. En route to San Francisco, the fleet made frequent stops in South American ports to promote goodwill, as well as to take on oft-needed coal. Naval historian James R. Reckner wrote, "Unprecedented in distance steamed, size of the fleet, and many other aspects, the voyage commanded the world's attention. A million people lined the Golden Gate to watch the Fleet's arrival in San Francisco. Indeed for most, the sight of 16 gleaming white, first-class battleships was the dramatic event of a lifetime."

After a two-month layover in San Francisco, *Georgia*, in company with the other battleships and auxiliary vessels, departed in July 1908. The second leg of the cruise took them to the Philippines, Australia, China and Japan. In Sydney, 500,000 people turned out to greet the ships, a remarkable number for a city whose total population was 600,000. While en route to Japan, the fleet ran into "the worst typhoon in 40 years." Fortunately, all the ships survived, as well as a sailor who was washed overboard by a huge wave, which then swept him onto the deck of another ship!

In Japan, despite recent tensions with the United States, the visit was surprisingly successful. Following the fleet's departure, diplomats from the two powers negotiated the Root-Takahira Agreement. Many feel that this settlement delayed conflict between Japan and the United States for a generation.

The next stage of the cruise took the fleet across the Indian Ocean and through the Suez Canal to the Mediterranean Sea. At a particularly narrow point in the canal, *Georgia* ran aground, a mistake that would shortly haunt its captain, Edward Qualtrough. Entering the Mediterranean, the fleet split up because of requests for visits from virtually every country bordering the Mediterranean. A massive earthquake near Messina, Sicily, gave the fleet an unusual opportunity to respond to a humanitarian crisis. Ships with supplies and medical personnel were dispatched to aid the stricken city.

Following a stop at Marseilles, *Georgia* was sent to Tangier to honor the anti-German sultan and reassure England and France that the United States stood with them against Germany in a dispute over Morocco. En route, *Georgia* ran into a storm, causing Captain Qualtrough to remain on the bridge throughout the night. Upon reaching Tangier, the exhausted captain apparently drank too much at a reception and was placed under arrest by his division commander, Admiral Wainwright, for "drunkenness

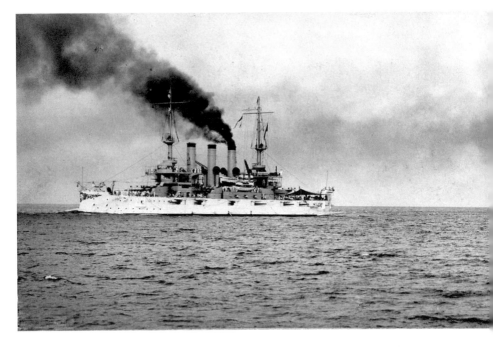

The Great White Fleet underway. In 1907, President Theodore Roosevelt sent sixteen battleships on a forty-six-thousand-mile cruise around the world. *Courtesy of Naval Historical Center.*

on duty." Qualtrough protested that he had only had "a glass of sherry and a cigar." Already under a cloud for the Suez grounding, however, he was court-martialed and returned to the United States, a prisoner in the ship he had commanded.

Following a two-week stay in the Mediterranean, the fleet crossed the Atlantic, entering Chesapeake Bay on February 22, 1909, coincidentally Washington's Birthday. "Brilliant End of World Cruise" shouted the headlines. At Hampton Roads, the fleet was again reviewed by President Roosevelt, whose term was to expire in two weeks. The president saluted the crews by saying, "This is the first battle fleet that has ever circumnavigated the globe. Those who perform the feat again can but follow in your footsteps."

Although there were a few negative aspects to the voyage, military historians consider the cruise a diplomatic and nautical success. In addition to enthusiastic receptions in forty ports on six continents, fleet commander Rear Admiral Sperry reported, "The long hours of station-keeping have paid off. The 16 ships are jogging along as if they were tied together." He added, "Removing the Fleet from East Coast shipyards meant that the crews had to rely on their own skills for maintenance and repair."

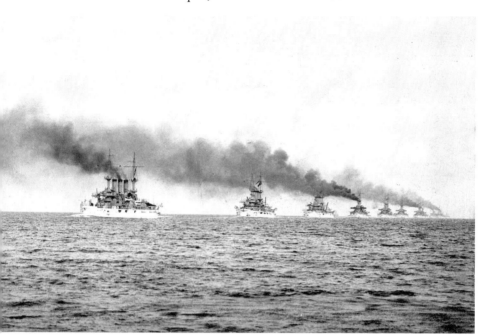

Three historic figures welcome the return of the Great White Fleet, February 22, 1909. Can you identify them? *Courtesy of Naval Historical Center.*

The Bath-built *Georgia*, along with the other battleships, was given an immediate and extensive overhaul and modernization. The top-heavy superstructure was reduced, lightweight guns were replaced by heavier pieces and new fire controls were added. The gold scrollwork was removed and every ship was painted what was to be known as "battleship gray." *Georgia* remained on active duty until 1920, serving all over the world, including in World War I. It was decommissioned and in 1923 sold for scrap under the terms of the Washington Naval Conference. As for Qualtrough, he was pardoned and retired from the navy in June 1909 with the rank of commodore.

PART VI

FUN AND GAMES

PLAY BALL, ISLAND STYLE

For a cold-weather state, Maine has a rich baseball tradition. The Baseball Hall of Fame lists seventy-one major leaguers who were born in Maine as of 2008. Summer leagues thrive all over the state, and Bangor has hosted the Senior League World Series since 2002. John Winkin, the legendary coach at the University of Maine, put the state on the collegiate baseball map by leading the Black Bears to the College World Series six times from 1975 to 1996. Louis Sockalexis, a Penobscot Indian, became the first Native American to play professional baseball at the major league level. He played with Cleveland from 1897 to 1899. His brief but brilliant career inspired the nickname "Indians," the name the Cleveland team still uses today.

Bobby Coombs, my baseball coach at Williams College in the late 1950s, was a good example of a Maine ballplayer. Bobby was born in Goodwins Mills, Maine, and was a longtime resident of Ogunquit. Bobby pitched for the Philadelphia Athletics and the New York Giants in the 1930s and '40s and was one of three generations of Coombses who pitched in the majors. His uncle Jack, the "Colby College Carbine," won 159 games for the Philadelphia Athletics and the Brooklyn Dodgers, including a 31–9 record in 1910.

Like all good coaches, Bobby was full of stories. He especially admired Carl Hubbell. "Not only was he a great pitcher, he was a terrific guy," Bobby recalled. "My locker was next to his. The only difference between us was that he had twenty pairs of shoes and I had two." Bobby's claim to fame was that the first batter he faced in the big leagues in 1933 was Babe Ruth. Guess what happened? Not surprisingly, the Babe hit a home run on a 3–2 count.

Island baseball in Maine, specifically on Vinalhaven, has its own rich tradition. Even nearby Hurricane Island had a team. In the late nineteenth century, Vinalhaven was a prosperous island community of 2,800 people, about twice the number of year-round residents living there today. The

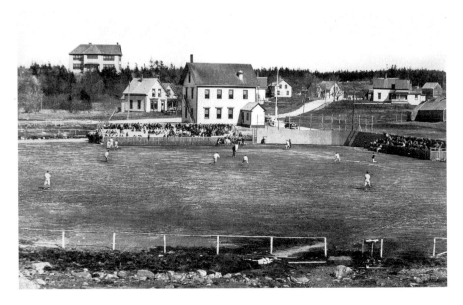

The Old Ball Ground, Vinalhaven. Tidal gates were put up along the third base line to prevent the field from flooding at high tide. Environmental regulations currently prohibit damming up what has become a protected wetland. *Courtesy of the Vinalhaven Historical Society.*

Bodwell Granite Company was the largest granite company in the United States, the Lane and Libby Fisheries was doing a booming business and baseball was already flourishing at the high school level. Before his death in 1887, Moses Webster, vice-president of the Bodwell Granite Company, donated a large parcel of land for a baseball field near Indian Creek, which he had cleared, drained and filled with tons of granite and grout at his own expense. In that era of baseball fanaticism, however, the town wanted a team to root for through the summer months as well. Thus, in 1900, the Vinalhaven Reds were formed.

Initially the team was composed of outstanding players from previous high school teams, although gradually the hometown boys were dropped and semiprofessional players from out of town were added. The Reds played two games a week from mid-June to Labor Day. When there was a home game, stores on Main Street closed and the quarries and fish factories were practically deserted. The fans' dedication to the Reds knew no bounds. They followed the team everywhere. In 1904, returning from a game against Belfast with a boatload of spectators, the steamer *Castine* broke its steering cable—following this, the captain became disoriented in a thick fog off Islesboro. There was no food or drink onboard, and 135 people spent a long, cheerless night anchored near Islesboro before the *Castine* crept

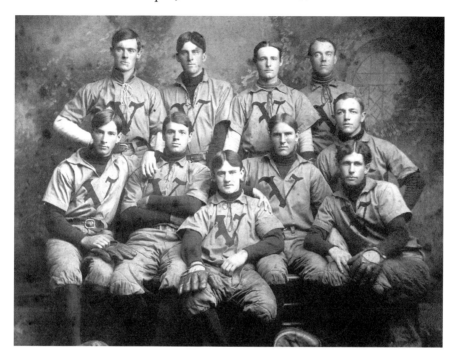

The Vinalhaven Reds were the town's semipro team in the early 1900s. The Reds won the Knox County pennant in 1904. *Courtesy of the Vinalhaven Historical Society.*

toward Carver's Harbor the next morning. It arrived just in time to hear the 7:00 a.m. whistle summoning people to work. Alas, after winning the Knox County pennant in 1904, the Reds, and indeed the whole league, were dissolved, having become too expensive an operation.

Bill "Dasher" Murray was born on Vinalhaven in 1893 and, to date, is the only big league ballplayer the island has produced. Murray played at Brown University (a college powerhouse in those days), and in 1916 and 1917, he was an infielder for the Washington Senators in the American League. In 1916, he played under the fictitious name of "Leonard," since he had not yet graduated from college. Murray enlisted in the army at the end of the 1917 season, the United States having just entered World War I. When he returned from the war, the Senators offered him a contract, but he opted for Harvard Law School. Baseball was in his blood, however, and in 1922 he accepted a job as the coach at Boston University. He is hailed as the coach who discovered the future Hall of Fame catcher Mickey Cochrane.

For the first half of the twentieth century, baseball was the sport of choice for Vinalhaven boys and young men. Almost any fairly level plot of land relatively free of rocks, trees and frog ponds was considered suitable for the

pickup games that thrived all over the island. The high school team won four straight Knox and Lincoln League championships from 1931 to 1934 and two more in 1938 and 1939. Allan Middleton (VHS '34) was the star pitcher for the 1931–34 teams and was signed by the Red Sox when he graduated. He worked his way up through their farm system before joining the air force at the start of World War II. Middleton was the first islander to be killed in the war when his plane was shot down in January 1943 over North Africa. Allan Middleton's baseball heroics, however, inspired a whole generation of Vinalhaven athletes, including Albert "Brud" Carver (VHS '46), who remembers Middleton as a "hard-throwing, fluid left-hander."

One of the results of the Depression on Vinalhaven was the improvement of the playing field by the WPA in the 1930s. It is known today as the "Old Ball Ground." Harold "Ducky" Haskell (VHS '40) recalled:

The field had stands for several hundred people along the baselines, as well as dressing rooms and a public address system. We were our own groundskeepers.

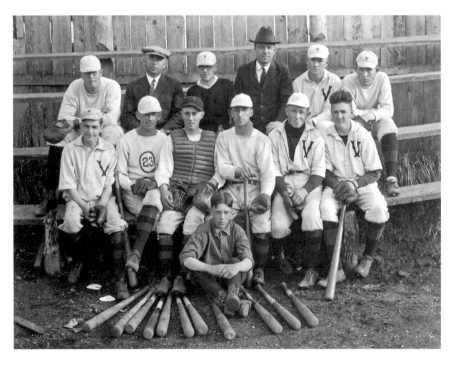

Vinalhaven High School baseball team, 1923. For the first half of the twentieth century, baseball was the sport for Vinalhaven boys and young men. *Courtesy of the Vinalhaven Hisorical Society.*

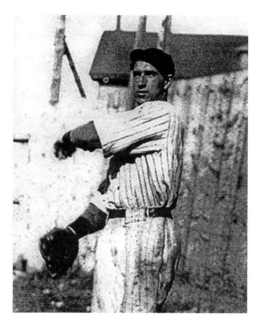

An outstanding high school pitcher, Allan Middleton, Vinalhaven High School, 1934, was signed by the Red Sox, though he never made it to the Major Leagues. Middleton died in World War II. *Courtesy of the Vinalhaven Historical Society.*

We hauled in sawdust then rolled and raked the field Sunday mornings (Blue Laws prohibited Sunday games before 1:00 p.m.). We even put in tidal gates along the third base line so the field wouldn't flood at high tide.

The field has produced its share of stories, including the time when, as Annette Philbrook (VHS '53) remembers, "Someone tried to hang himself in the clubhouse." Today the Old Ball Ground is used for winter skating parties, since environmental regulations prohibit damming up what has become a protected wetlands area.

A few years ago, Jim Baumer, a Portland writer, wrote a delightful book entitled *When Towns Had Teams*. The book describes the thirty-year period in the middle of the twentieth century when men of all ages played baseball at the semipro and town team level throughout the state. Baumer, who played the sport himself, wrote the book as a tribute to the men who also played.

Baumer uses the baseball scene in Maine to illustrate the changes that were occurring in American society in the 1950s. "High school graduates from all over the country were deciding on college as an option to jump start their careers." One result of this influx of manpower was the development of a more competitive brand of college baseball. This, in turn, improved the level of summer ball played at the semipro and town team level in Maine. The result was that spectators of the sport were treated to a high

level of baseball from early summer until the last major league team had barnstormed through the state in the fall.

Vinalhaven's version of *When Towns Had Teams* occurred when the Chiefs, the town's semipro team, were formed. The Chiefs had nice uniforms and warm-up jackets paid for by local businessmen. According to Val "Buzz" Young (VHS '53), being asked to play for the Chiefs was a "big deal" for a high school kid in the 1950s. Brud Carver, who played first and pitched for the Chiefs in the '40s and '50s, recalls that teams came from as far away as Augusta and Lewiston. "We liked playing teams from away. They were exhausted before we even started. We would pass the hat and split the take with them. We usually just about broke even."

One of the highlights of Vinalhaven baseball during this period was the night game the Chiefs played against a strong team from Warren on August 3, 1949. Portable lights were brought over from Rockland and set up along the baselines. To quote from Ivan Calderwood's account of the game:

> *Now remember, these two teams had never played under lights, never caught a ball as it appeared from the sky at night. They played like old pros. Those boys out on the field would pick those flies out of the sky like picking apples from a tree. What a thrill it was when Clyde Bickford belted a home run to win the game. It surely was a night of nights. Like the Red Sox playing the Yankees.*

Some things never change.

Buzz Young recalls the impact that World War II had on Vinalhaven baseball. "Mainland teams were reluctant to cross the [Penobscot] bay to play us because they were afraid of German submarines lurking in the area. The subs would surface in the fog off Seal Island and we could hear them recharging their batteries." Transportation from the island to the mainland was equally difficult because the regular ferries were taken by the navy for use as troop transports, leaving intrepid lobstermen's boats as the main source of transportation.

After a lapse of fourteen years, the 1953 high school team won the Knox–Lincoln County championship. Following an opening game loss to Camden, the team won the rest of its games. In the following years, however, fewer and fewer boys came out for the team until the sport was discontinued after the 1959 season. Young men were leaving the island to work on the mainland. Basketball was becoming increasingly popular, and by the late 1950s, there were the distractions of television. My own experience with Vinalhaven baseball coincided with the decline of the sport on the island.

I played a few games with the Chiefs in 1956. Although we didn't know it at the time, it was to be the last year of the team's existence. Once the Chiefs disbanded, the wooden stands around the Old Ball Ground began to crumble, and eventually the field itself was off-limits to baseball because of environmental regulations.

For the next forty years, there were sporadic attempts to resume baseball on Vinalhaven that came to naught. Finally in 1998, Steve Ames and Duey Sanborn were able to launch a Little League program that has taken off in the last decade. "We knew the interest was there. It was just a question of organizing the kids," said Steve. Interest in the sport has grown to the point where a Babe Ruth team was formed in 2003 and the high school fielded a team in the spring of 2005.

"Baseball Returns to Island in a Big Way," read the June 5, 2003 headline in the *Rockland Courier-Gazette*. The 2004 Babe Ruth team played its home games on the recently completed field behind the new school and received a lot of publicity in the local press. "Everyone is up for baseball and for seeing that these kids have some of the same opportunities the kids on the mainland have," to quote Jim Conlan, manager of the Babe Ruth team at the time. "The reemergence of baseball on the island is good to see because it was an important sport here for so long. People here remember playing or watching games on the old ball field. Having baseball on the island again will bring out the fans, and that will be a great thing to see."

Baseball returned to Vinalhaven with the formation of a Little League team in 1998 and a Babe Ruth team, pictured here, in 2003. *Courtesy of the Vinalhaven Historical Society.*

Two years ago, a number of Vinalhaven's "older generation" turned out for a baseball event when Robin Roberts, the Philadelphia Phillies Hall of Fame pitcher from the 1950s, came to Vinalhaven to visit his good friend Shel Gordon. Roberts was the guest of honor at a Lions Club dinner, which unsurprisingly attracted a large crowd. As the evening wore on, everyone relaxed and listened to the old right-hander tell stories about his baseball experiences.

Roberts talked about his own career and his futile negotiations with Phillies owner Bob Carpenter. When he went in to ask for a raise after winning twenty games for the fourth year in a row, Carpenter refused, saying that would "blow his payroll." We were reminded there were no agents in those days. Roberts talked about pitching to Red Sox immortal Ted Williams in a spring exhibition game. When he struck the slugger out with a slow curve, the intense Williams responded with a string of expletives. "In his next at bat, Williams got hold of a fastball and hit a home run which is probably still going," Roberts mused. "Ted could get even in a hurry."

The other time Roberts faced the legendary Boston star was in the 1950 All-Star game in which he was the starting pitcher for the National League. In the first inning, Williams broke his elbow crashing into the outfield wall. Nevertheless, he insisted on staying in the game. Facing Roberts he hit a vicious line drive that second baseman Jackie Robinson barely managed to catch. "It is unbelievable that Williams could hit a ball that hard with a broken elbow, but he did," Roberts reflected.

During the course of the evening, Roberts reminisced about his pitching duels with Dodger great Don Newcombe. He talked about losing a game to Sandy Koufax, when the Dodger lefty pitched a three-hitter. "And I had two of the three hits," Roberts noted. Roberts lost the only World Series game he ever pitched to the Yankees in 1950 by a score of 2–1. Joe DiMaggio won the game with a home run in the tenth inning.

When asked about his visit to the island, Roberts said he thoroughly enjoyed his stay and added, "I never realized there was such a hotbed of Red Sox fans this far from Fenway Park." Baseball has indeed returned to Vinalhaven.

THE GAME: NORTH HAVEN V. VINALHAVEN

"The Game." You've heard the expression that describes a traditional athletic rivalry between high schools and colleges: Army-Navy, Harvard-Yale, Portland–South Portland, Camden-Rockland, Bangor-Brewer and so on. Out

on two Penobscot Bay islands, there is the Vinalhaven–North Haven basketball game that, over the years, has been just as intense as any of the above.

It would appear to be an unequal contest, since Vinalhaven is a considerably larger community. In 2008, the Vinalhaven School had 193 students and a year-round island population of about 1,300 people. By comparison, the North Haven School opened with 65 students and an estimated year-round population of 380 on the island.

Although they are very different island communities, the two towns also share a number of things in common, not the least of which is that they both have new schools—Vinalhaven's school opened in 2003 and North Haven's $8 million facility opened in the fall of 2008. Vinalhaven has a high school enrollment of sixty-three students, whereas North Haven has twenty-five students in grades nine through twelve. Despite an obvious disparity in size, the two islands share an athletic rivalry that has been played out most often on the basketball court.

The basketball rivalry goes back for years and not surprisingly favors Vinalhaven in terms of wins and losses. On Vinalhaven, there are few references to basketball before the 1930s. Baseball was *the* sport. The 1939 yearbook, *The Exile*, noted, however, that "winter basketball was revived for the first time in a few years. Boys and girls showed unmistakable interest. Neither team, however, was able to play out-of-town teams, because of the boat schedule." By 1950, however, the Vinalhaven yearbook informs us that the boys played two games with North Haven and lost them both, 40–38 and 26–17. "This was the first time we have had a team in some time due to the fact that we had no hall in which to play," the yearbook concluded.

In the first half of the twentieth century, North Haven athletes at least had a court on which to play. Basketball was played in the Grange Hall until 1924, when the venue was moved to Calderwood Hall (now a gift shop). Then, in 1959, the Community Building was built. Although not regulation size, it served as a place to play until the present gym was completed for the 2008–9 season. "It was a real bandbox," one player remembered. "We probably broke every fire regulation in the book"

A former Vinalhaven player remembers a close game in the Community Building years ago when the seam on his pants split down the back (pants were shorter and tighter in those days). The wall of the building was practically at the baseline. When the boy had to take the ball out of bounds, he found he was standing directly in front of two elderly ladies who were spectators. I'll leave their reaction to your imagination.

The current North Haven girls' coach, Roman Cooper, remembers playing for North Haven boys' teams in the early 1980s when his father was

Vinalhaven girls high school basketball team, 1930s. *The Exile*, the high school yearbook, tells us that in the 1930s the boys and girls teams found it difficult to play off-island games because of the "boat schedule." *Courtesy of the Vinalhaven Historical Society.*

North Haven High School boys team, 1955. Players described their gym as "a real bandbox." *Courtesy of the North Haven Historical Society.*

coaching. "We had a very intense rivalry back then. There was a good deal of animosity." Roman mentioned a 1984 game that got "pretty physical." At one point, his dad and the Vinalhaven coach had to step in, stop the game and "cool the guys down." "The last few years the girls' games, especially, have been very competitive, after being dominated by Vinalhaven for years," Cooper added.

Dennis Pratt, longtime Vinalhaven athletic director and the boys' coach until 2008, said, "They'll bring a bus down for the game in December and the place will be packed for both the boys' and girls' games. Then we'll go up there in January for a return game. Once in a while North Haven wins a game and you'd think they'd won the NBA Championship."

Chuck Curtis graduated from the North Haven School in 1976 and played against Vinalhaven teams starting when he was in eighth grade. "We never beat them," Chuck groaned. "The Vinalhaven players were these big, tough guys with beards. They all looked like they were thirty!" Curtis later coached the North Haven boys' team for several years. "Vinalhaven had a huge home

The Vinalhaven v. North Haven basketball game in 1980. In the 1980s, the two schools had a very intense rivalry. *Courtesy of the North Haven Historical Society.*

court advantage because their old gym was so deafeningly loud. A few years ago we actually beat them for the first time in twenty years."

If the rivalry between the two schools is a bit less intense these days, it is because students from each school have more opportunities to get to know each other than in the past. For example, the Inter-Island Arts Festival brings students from the two schools together. Both Waterman's Community Center on North Haven and the ARC (Arts and Recreation Center) on Vinalhaven have programs that attempt to include children from the other island. Tristan Jackson, who runs the ARC, said, "Last year some kids from North Haven came down here for a dance and later some of our kids went to their prom."

Sometimes athletes play together on joint teams. For a number of years, the two schools have combined for cross-country, and sometimes a player from North Haven will play on the Vinalhaven soccer team, since North Haven doesn't offer the sport. And the rowing teams from both islands have developed a competitive, though friendly, relationship.

Vinalhaven and North Haven remain very different communities, though relations between the schools are becoming closer. Roman Cooper describes today's rivalry as

> good natured whereas it used to be bitter and more competitive. Now the kids intermingle more...There is more emphasis on sportsmanship and we shake hands after games. Families are getting to know each other and there is a greater sense of community. In my day we never did the things together they do now.

NORTH HAVEN DINGHY STORIES

They are marvelous boats. You really feel close to the water, sometimes almost too close.
—Kim Pendleton

An island in the middle of Penobscot Bay has the honor of having the oldest active racing class in North America, possibly the oldest in the world. The story of the North Haven Dinghy is closely tied to the beginnings of the North Haven summer community.

In the early 1880s, William F. Weld was cruising on Penobscot Bay with several Boston friends looking to buy some land. Their hope was to find a place to spend the summer that was more relaxed than the formal atmosphere of resorts like Bar Harbor.

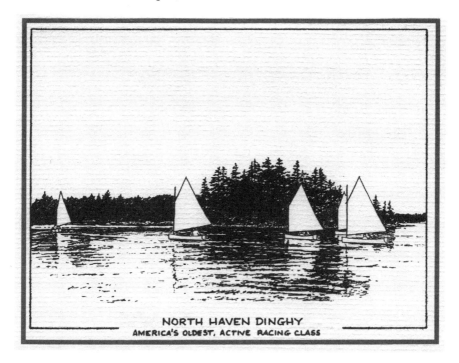

The Dinghy Race. The first North Haven Grand Dinghy Race was held in 1887. *From a card by North Haven artist Herbert Parsons.*

When they got to Isle Au Haut, Weld heard of a boardinghouse on North Haven where his party could stay while looking around. Upon visiting the island, Weld and his friends were so captivated by the place that they stopped their search, purchased land and engaged local carpenters to construct summer homes. Sources agree that by 1883 a summer colony had begun, although the larger summer "cottages" on the Fox Islands Thorofare didn't begin to appear until the early 1890s.

Before the days of motorboats, small sailboats were used for transportation in the waters around North Haven. As the island began to attract summer residents, some of the more competitive vacationers on the island began to race their dinghies informally. In 1883, William Weld had three sailing tenders onboard his yacht *Gitana*. To his dismay, the dinghies were soundly beaten in informal races by local craft rigged with sprit sails. Not to be outdone, Weld returned the next year with a faster dinghy and proceeded to beat all comers.

Informal small-boat racing continued for the next two years until the first "Grand Dinghy Race" was held in August 1887. History tells us that

there was a preliminary event between three female sailors, Mrs. Cobb, Miss Spencer and Miss Ellen Hayward, in which Hayward emerged the winner. The second race was a three-way contest between two men, Charles Cobb and Dr. Charles Weld (William's brother), and Ellen Hayward.

Fifty years later, in 1937, Ellen Hayward Wheeler described the race: "Dr. Weld and Mr. Cobb were experienced yachtsmen and keen racers who kept trying to blanket each other, with the result that I, who knew nothing about racing, won the race." And thus the oldest racing class in North America was born. It is said that Dr. Weld graciously presented Ellen Hayward with a sloop, *Wayward*, which she and her husband, Henry Wheeler, sailed for many years on Penboscot Bay.

By 1919, variations in the dinghy design had reached the point that a committee was formed to standardize plans for future boats. North Haven boat builder Edwin "Bud" Thayer says that in 1929 the "North Haven Yacht Club got together and finally settled on the dimensions for the boat." The dinghy was to be gaff-rigged, fourteen feet, six inches long, with a beam of four feet, eleven inches and a draft of thirteen inches, with the centerboard raised. It should carry 350 pounds of ballast.

One of the reasons that the dinghy has remained popular for over a century is because its design has essentially stayed the same, with only minor modifications. Early dinghies, however, had no flotation tanks. Apparently William Weld felt that they weren't necessary for good sailors. Then one of his boats capsized and sank. From then on, air tanks were standard.

For the first century of the dinghy's existence, Brown's Boatyard in North Haven was the primary builder of the dinghy. In fact, the J.O. Brown & Son Boatyard celebrated its centennial in 1988. Brown's built and repaired most of the class until the mid-1970s, when fiberglass boats began to appear. Few wooden dinghies have been built since. Today about twenty dinghies remain on North Haven, most of which are the easier-to-maintain fiberglass hulls. The hope is this will also help keep the class alive.

Bud Thayer

Bud Thayer, now in his eighties, estimates that there were one hundred wooden dinghies built originally. "I've worked on a lot [he has built four] and rebuilt many more. Galvanized fasteners held the early ones together, so they'd rust out. Other times the keel would be bad, or the planks would open up." According to Bud, the fiberglass boats were faster, "though in a real good breeze the wooden ones would 'set up' just as good as the fiberglass."

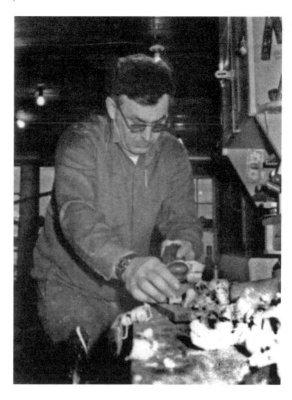

Bud Thayer, North Haven boat builder. Bud opened Thayer's Y-Knot Boatyard in 1969. *Courtesy of Thayers Y-Knot Boatyard.*

Bud laughed when he recalled building a boat for his good friend, Charlie Cabot, who died a while ago:

> *I probably shouldn't tell you this, but Charlie could never win a race. There was always something that went wrong with what he had. Once, when I had finished making a boat for him, his father came in and rubbed his hand along the gunnels. "You know Bud," he said, "it won't do a damn bit of good."*

Bud told me he crewed in a race with Charlie "and we came in last," which I guess was no surprise.

Another time, Bud remembers Charlie coming up to him and saying, "Bud, I won a race! I came in first." "How did you do that," Bud asked. Charlie said, "I was the only boat." Bud told him, "And you also came in last, which you were always doing."

Bud told me that the North Haven dinghy was used in other ways too. "Once they tried to turn one into a launch. They put in a four-cylinder motor and that didn't work, so they put an outboard on her, but neither

worked." The boat Bud was referring to is *Phoenix*. David Parsons described it as having been "converted back to a sailing dinghy, subsequently fiber glassed and having gone on to win many races...*Phoenix* has since been retired and now graces the Casino [Yacht Club] steps as a planter, awaiting her next reincarnation."

Then there is the story of a young woman, an experienced sailor from Connecticut, who was visiting some friends on North Haven. When she went out in their dinghy she was so impressed with the boat that she bought one and took it home to Greenwich, where she entered it in the annual Labor Day "all comers" race. To everyone's surprise, she finished first! Two years later, she repeated her victory.

A Non-Racing Dinghy Story

North Haven resident Lew Haskell tells a dinghy story that has nothing to do with racing. In the summer of 1933, he and two summer friends from Brooklyn, New York, sailed a dinghy across Penobscot Bay to Camden, where Lew needed to get some parts and a permit for a motorboat he had been given. The trip to Camden was uneventful, other than the fact that halfway across the boys realized that they had neglected to tell their parents where they were going. Lew also admitted that one of his friends couldn't swim and that the dinghy had no lifejackets or instruments.

By the time they were ready to leave Carlie Anderson's boatyard in Camden, it was 5:00 p.m. and the fog had rolled in. Carlie urged them not to go, but Lew said they refused, since they hadn't told their parents where they had gone, nor could they call, since none of the families had a phone. "Carlie tried to talk us out of it, but to no avail. Finally he gave up, loaned us a compass and watched us blunder out into the fog."

Halfway across the bay, the wind came up and the dinghy tipped over. To their credit, the boys did not panic. Lew said they tied their nonswimming friend to the boat, which fortunately hadn't sunk because of the air tanks. When they got the mast down and jettisoned the ballast, the boat righted itself. Lew and the other boy then reset the mast and told their nonswimming companion to start bailing. At this crucial moment, they discovered an emergency kit stowed aboard that contained matches, a can of beans and oarlocks, which enabled them to row to Saddle Island, just south of Islesboro.

On Saddle Island, the boys lit a fire and put the can of beans in the embers to heat it up. Not surprisingly, it blew up, scattering beans everywhere. Lew said they poked around trying to find some of the beans, all the while being

attacked by swarms of mosquitoes. When the tide came in, they sailed the dinghy back to Pulpit Harbor and walked home, arriving about 11:00 p.m. The boys didn't tell their families where they'd been, though word got out the next day. I'll leave their parents' reaction to your imagination.

WHEN HOLLYWOOD CAME TO VINALHAVEN: THE FILMING OF *DEEP WATERS*

In the summer of 1947, Henry King, one of Hollywood's top directors, flew his plane over one thousand miles along the Maine coastline. King, an experienced pilot, was searching for just the right spot for his next film. It was on such a flight that he first observed Vinalhaven through a break in the clouds.

Sixty years ago, Henry King was considered by many to be "the father of location." "If the story is set in Maine, we'll shoot the picture in Maine," King announced when he first saw the script for *Deep Waters*. To King, "on location" meant exactly that. In this case, he was looking for a typical Maine lobster village. After giving careful consideration to Bar Harbor, Southwest Harbor and Port Clyde, King found the spot he was looking

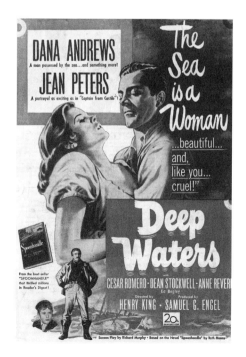

The cover of a movie magazine, featuring *Deep Waters*, which was shot on Vinalhaven. The film was nominated for two Academy Awards in 1948. *Courtesy of the Vinalhaven Historical Society.*

for and selected Vinalhaven. In fact, *Deep Waters* would be the third film he made about Maine.

"This is a wonderful spot," he is reported to have said. "Look at this natural setting we are shooting today," and he swept his arm in the direction of the Stanton Strawson summerhouse on the western side of the island. "If I had set this up in California, they would have told me it was too Hollywood." Strawson's son, Fred, recalled recently that his father was "so pleased and flattered to have his house selected that he accepted no money." Unfortunately, the dock and float that were built for the film, which Strawson could have used, had washed away by the following summer.

Deep Waters is loosely based on the 1946 bestselling novel *Spoonhandle* by Ruth Moore, who grew up on Gott's Island, south of Mt. Desert. Hollywood writers changed the name of the film to *Deep Waters*, explaining that the book's title, *Spoonhandle*, was not descriptive enough unless one had read the novel. Actually, the movie version of the book went through at least two adaptations before filming began. Having read the book and seen the movie, I would agree with critics who said that the script "wandered more than a little from what Moore would liked to have seen on the screen." In fact, Moore cut her ties with the production when she saw how the script had been "revised." Apparently, she never saw the film.

The screenplay is about an orphan boy (Dean Stockwell) who is placed in a foster home by a welfare worker (Jean Peters). Two fishermen, played by Dana Andrews and Cesar Romero, provide role models for the troubled youngster, who has been caught stealing and is sent to a reform school in South Portland. As the story unfolds, Stockwell develops a love for the sea and lobstering while Andrews and Peters fall in love with each other.

In addition to popular mid-twentieth-century actors Cesar Romero and Dana Andrews, the film featured twenty-one-year-old newcomer Jean Peters, making only her second film. Peters, "discovered" by Howard Hughes, whom she later married, had just finished playing opposite Tyrone Power in *The Captain From Castile*. World War II veteran Romero had seen combat in the Pacific before being mustered out in 1945. Dana Andrews had just completed the intense, highly charged movie *Daisy Kenyon* with Joan Crawford. Although he had never been to Maine, Andrews owned three boats in California and spent almost all of his free time on the water. Whenever he could, he and Romero loved to play hooky and go lobstering with local fishermen.

Ten-year-old Dean Stockwell played the orphan boy Danny Mitchell. Stockwell was already an established child star, with sixteen films to his credit. After spending a few days on the island, Dean was ready to forsake his Hollywood career and become a lobsterman. Twelve-year-old Johnny

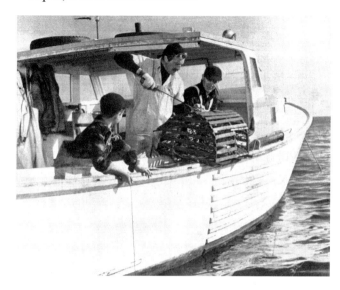

Actors Dean Stockwell, Cesar Romero and Dana Andrews hauling lobsters on *Hazel R. Courtesy of the Vinalhaven Historical Society.*

Bickford, a lifelong Vinalhaven resident, played Dean's stand-in. Another well-known cast member was Hollywood's perennial mother figure, Anne Revere, who played the role of Dean's guardian in the movie. As recently as 1945, she had won an Academy Award for best supporting actress for her role in *National Velvet.*

The filming took place in October 1947, when most summer people had left the island, although it was not released until 1948. Vinalhaven residents were thrilled by the reality of a Hollywood production. Director King spread the word that everyone was welcome to watch the shooting, and many were included as extras in various scenes. Meanwhile, island residents had opened their doors to house and feed the seventy-six members of the cast and crew.

"Why, they're just like we are" was the general feeling. Except for Sundays when most stores were closed, cast members took part in town life, eating ice cream at White's Drug Store, bowling and going to Saturday night dances. At one point, Andrews and Romero even persuaded the pool hall operator to stay open until 11:00 p.m., well past the usual closing hour. The visitors were also delighted by the price of lobsters, $0.30 per pound, which compared favorably to West Coast prices of $4.50 for a lobster dinner.

One of the popular stories stemming from the twenty-seven days of filming on the island had to do with King's passion for authenticity. This occurred when a local lobsterman, Lester Dyer, broke out laughing when he saw the shiny new boots that Cesar Romero and other fishermen actors were wearing. "What's so funny," King asked. Les replied that he'd been fishing for forty years and he'd never seen fishermen with such new boots. Thinking

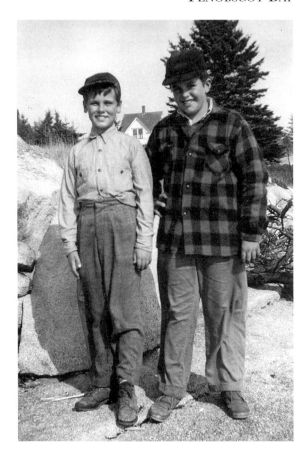

Left: Dean Stockwell (at left) and his stand-in, John Bickford, in front of the Strawson house on Granite Island. *Courtesy of the Vinalhaven Historical Society.*

Below: Townspeople watching the film crew at work on Main Street. The filming took place in October when summer residents had left the island. *Courtesy of the Vinalhaven Historical Society.*

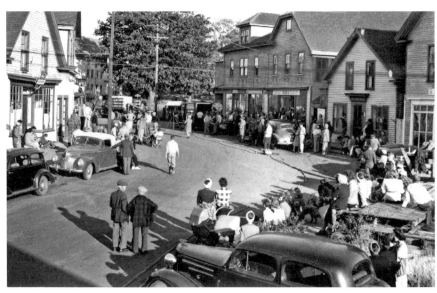

it over, the director was inclined to agree. "Where can I get my hands on a dozen pair of beat-up rubber boots?" he asked. "Give me and the boys about five minutes and we can work something out," Les replied. "And that was how it came to pass that the Hollywood crew got their beat-up boots and the local boys went to sea the next day outfitted in spanking new ones," reported *Down East* magazine. Incidentally, from then on Les Dyer was on the payroll as a paid consultant.

In 1948, *Deep Waters* was nominated for two Academy Awards—Best Visual Effects and Best Special Effects.

A TRIP TO TURNER

"Faster, Harry, faster! Get this crate moving!" These were the more polite words of encouragement that came from the passengers in my 1951 Ford as we hurdled down the road at eighty miles per hour heading toward Turner, Maine, in the summer of 1956. I pressed down on the accelerator, but with seven husky ballplayers onboard, my car had reached its limit.

Why was I going so fast on one of Maine's innumerable back roads? The short answer is that I was helping to transport a baseball team to Turner from Vinalhaven Island, a challenging land/sea operation. First, we had to take the ferry across Penobscot Bay to Rockland, where I had left my car. Then we had to find Turner.

Ever since I was a child, my family had gone to Vinalhaven for our summer vacation. Among other activities, we enjoyed watching the town baseball team, the Vinalhaven Chiefs, play a game or two. I loved baseball, whether it was played on Vinalhaven Island or at Yankee Stadium. As a boy, I knew and admired many of the local players: Brud Carver, Ducky Haskell, Sonny Oakes, Paul Chilles and Clyde Bickford.

Fifty years ago, Vinalhaven had a rich baseball tradition that began in the late nineteenth century. My own experience with Vinalhaven baseball unfortunately coincided with the decline of the sport on the island. In 1956, I was an enthusiastic left-handed pitcher of limited ability. Years later, the exact details of the Turner trip are a bit hazy, except that I know I was delighted, as a summer kid, to be asked to play on the team. (Could it be that the real reason I was invited to play was because I had a car available in Rockland?) Whatever the reasons, I remember my car was part of a caravan taking the Chiefs to play a game against a town that, at the time, seemed practically at the Canadian border.

The road to Turner. Turner is fourteen miles northwest of Lewiston, twenty miles east of Norway, thirty miles south of Mexico and thirty-five miles southwest of Vienna. *Courtesy of the Turner Historical Museum.*

In the mid-1950s, Vinalhaven was an island with approximately thirty miles of dirt or poorly paved roads. The condition of these roads kept anyone from even approaching the speed limit, whatever it was in those days. Once off the island, however, all bets were off. The young man driving the car ahead of me was clearly intoxicated by the open roads of the mainland and was determined to take advantage of this rare opportunity to see how fast his car could go, which in this case was considerably faster than mine.

And so we proceeded to Turner. After what seemed like an eternity of bumpy roads, we arrived safely at our destination. Turner, for those you unfamiliar with the geography of inland Maine, is about fourteen miles northwest of Lewiston. It is also twenty miles east of Norway, thirty miles south of Mexico and thirty-five miles southwest of Vienna, if that helps. To be fair, I should add that Turner was actually a pretty little farming community nestled in the foothills of the western part of the state.

I don't remember the details of the game except that I pitched a bit and I think we won. I do remember that the field was laid out on a sloping village green, which I understand has since been leveled off and is now an elementary school playground. In those days, the outfield dropped off

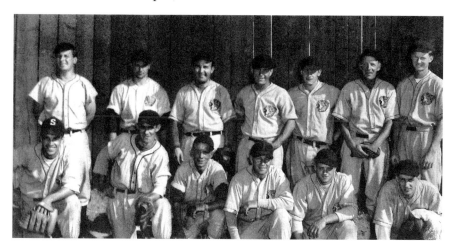

The Vinalhaven Chiefs, mid-twentieth century. The Chiefs played teams from as far away as Augusta and Lewiston. "We liked playing teams from away. They were exhausted before we even got started," said Brud Carver, former Chief. *Courtesy of the Vinalhaven Historical Society.*

so much in center and left field that, as I stood on the pitcher's mound, our outfielders were only visible from the waist up. The result was that fly balls hit by both teams were frequently misjudged once they got beyond the infield. In medium right field there was a large private house that looked like a church. The ground rule was that any ball coming into contact with this imposing structure was an automatic double. There was only one umpire. He was stationed behind home plate and was berated on just about every call he made. Heckling the umpire was clearly part of the game in Turner.

I played in several more games with the Chiefs that summer of 1956, and I was looking forward to subsequent summers with the team. Unfortunately, interest in baseball was declining on the island, and as noted, the team was disbanded after the 1956 season.

However, what goes around comes around. Vinalhaven began a Little League program in 1998, which is flourishing. This in turn led to the formation of a Babe Ruth team in 2003, and in 2005 the high school team was reestablished. Who knows? Maybe the boys will even take another trip to Turner.

Bibliography

Anderson, Will. *Was Baseball Really Invented in Maine?* Portland, ME: Will Anderson Publisher, 1992.

Baumer, James. *When Towns Had Teams*. Lewiston, ME: RiverVision Press, 2005.

Beveridge, Norwood P. *The North Island, Early Times to Yesterday*. North Haven, ME: The North Haven Bicentennial Committee, 1976.

Bissell, Esther, and Roy Heisler. *Images of America: Vinalhaven Island*. Charleston, SC: Arcadia Publishing, 1997.

Blow, Michael. *A Ship to Remember: The Maine and the Spanish-American War*. New York: William Morrow & Co., 1992.

Buker, George. *The Penobscot Expedition: Commodore Saltonstall and the Massachusetts Conspiracy of 1779*. Annapolis, MD: Naval Institute Press, 2002.

Calderwood, Ivan. *Days of Uncle Dave's Fish House*. Rockland, ME: Courier-Gazette, 1969.

Caldwell, Bill. *The Islands of Maine*. Portland, ME: Guy Gannett Publishing Co., 1981.

Callahan, North. *Henry Knox: General Washington's General*. New York: Rinehart & Co., 1958.

Clark, Charles E. *Maine, A History*. Hanover and London: University Press of New England, 1977.

Ellis, Joseph. *American Creation*. New York: Vintage Books, 2007.

Grindle, Roger. *Tombstones and Paving Blocks*. Rockland, ME: Courier-Gazette, 1977.

Kershshaw, Ian. *Fateful Choices. Ten Decisions That Changed The World, 1940–1941.* New York: Penguin Books, 2007.

McLane, Charles, and Carol E. McLane. *Islands of the Mid-Maine Coast: Penobscot Bay*. Gardiner, ME: Tilbury House, 1998.

Meacham, Jon. *Franklin and Winston*. New York: Random House, 2003.

Merriam, Paul G., Thomas J. Molloy and Theodore W. Sylvester Jr. *Home Front on Penobscot Bay: Rockland During the War Years 1940–1945*. Rockland, ME: Rockland Cooperative History Project, 1991.

Moore, Ruth. *Spoonhandle*. Nobleboro, ME: Blackberry Books, 1946.

Puls, Mark. *Henry Knox: Visionary General of the American Revolution*. New York: Palgrave Macmillan, 2008.

Reckner, James. *Theodore Roosevelt's Great White Fleet*. Annapolis, MD: Naval Institute Press, 1988.

Rich, Louise Dickinson. *The Coast of Maine*. Camden, ME: Down East Books, 1975.

Richardson, Eleanor Motley. *Hurricane Island: The Town That Disappeared*. Rockland, ME. Island Institute, 1989.

Thorndike, Virginia. *Islanders, Real Life on the Maine Islands*. Camden, ME: Down East Books, 2005.

Van Horn, David. *A Brief History of Penobscot Bay*. Castine, ME: Robert's Press, 2003.

Weems, John E. *The Fate of the Maine*. College Station: Texas A&M University Press, 1992.

Wimmel, Kenneth. *Theodore Roosevelt and the Great White Fleet*. Dulles, VA: Brassey's, 1998.

Winslow, Sidney. *Fish Scales and Stone Chips*. Portland, ME: Machigonne Press, 1952.

Archival materials consulted at the following locations:

Bangor Public Library, Bangor, Maine
Bar Harbor Historical Society, Bar Harbor, Maine
Calvert Marine Museum, Solomons, Maryland
Islesboro Historical Society and Museum, Islesboro, Maine
Maine Maritime Museum, Bath, Maine
National Baseball Hall of Fame, Cooperstown, New York
North Haven Historical Society, North Haven, Maine
Patton Free Library, Bath, Maine
Penobscot Marine Museum, Searsport, Maine
Portland Public Library, Portland, Maine
Rockland Historical Society, Rockland, Maine
Rockland Public Library, Rockland, Maine
Roosevelt Presidential Library, Hyde Park, New York
Vinalhaven Historical Society, Vinalhaven, Maine
Vinalhaven Public Library, Vinalhaven, Maine

ABOUT THE AUTHOR

Harry Gratwick is a lifelong summer resident of Vinalhaven. He first visited the island as a child during the 1940s. As a young man in the 1950s, he played on the town's baseball team and explored the waters around Vinalhaven by outboard. As an adult, he has cruised the Maine coast from Casco Bay to Mt. Desert.

Recently retired, Gratwick enjoyed a forty-six-year career as a secondary school history teacher, coach and administrator. He spent most of these years at Germantown Friends School in Philadelphia, Pennsylvania, where he chaired the History Department and coached the varsity baseball team.

The stories in this book combine two of Harry's passions—his love of history and of the sea. He is an active

Photo of author by Steve Gratwick.

member of the Vinalhaven Historical Society and has written extensively on maritime history for two Island Institute publications, *Working Waterfront* and *Island Journal*.

Gratwick is a graduate of Williams College and holds a master's degree from Columbia University. Harry and his wife, Tita, spend the winter months in Philadelphia. They have two grown sons, a Russian daughter-in-law and two grandsons.

Visit us at
www.historypress.net